The Art of
PASTEL PAINTING

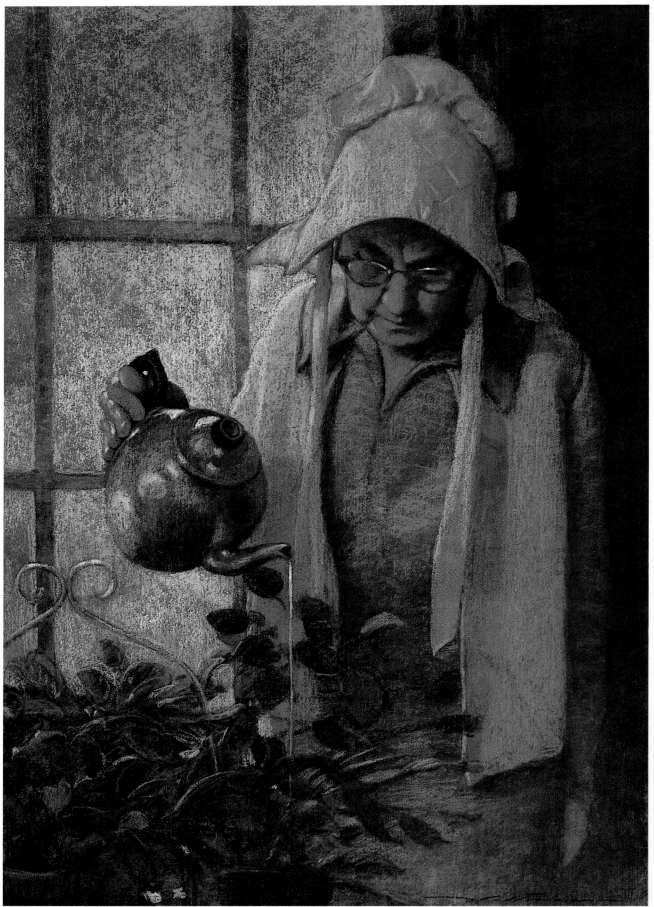

DAILY CARE, *granular board, 29" × 20" (74 × 51 cm). Collection Mr. and Mrs. Howard E. Stover.*

The Art of
PASTEL PAINTING

Alan Flattmann

WATSON-GUPTILL PUBLICATIONS / NEW YORK

There are a number of people who were instrumental in the development of this book and deserve my sincere appreciation. First is Bryant Allen, president of Bryant Galleries, who originally proposed the book and has enthusiastically encouraged my pastel work for many years.

I want to thank Joyce Kelly for her invaluable help in preparing the manuscript and assistance in taking many of the photographs; Gayle Flattmann, for her perseverance and extraordinary skill in typing the manuscript from my dictation and illegible handwriting; Joan Lissy for her proofreading and excellent suggestions; and my wife, Becky, for her help with the initial development of the book.

I am also grateful to conservators Verne T. Clark of Covington, Louisiana, Marjorie B. Cohn of the Fogg Museum, Katherine G. Eirk of the National Museum of American Art, and David Chandler of the Art Institute of Chicago for their expert advice regarding the care of pastels.

Finally, I want to express my gratitude to Watson-Guptill Publications and to my editor, Bonnie Silverstein, for believing in the merits of the book.

Copyright © 1987 by Alan Flattmann

First published 1987 in New York by Watson-Guptill Publications, a division of Billboard Publications, Inc., 1515 Broadway, New York, N. Y. 10036

Library of Congress Cataloging in Publication Data

Flattmann, Alan.
 The art of pastel painting.

 Bibliography: p.
 Includes index.
 1. Pastel drawing—Technique. I. Title.
NC880.F53 1987 741.2'35 87-14784
ISBN 0-8230-0274-8

Distributed in the United Kingdom by Phaidon Press Ltd., Littlegate House, St. Ebbe's St., Oxford

Manufactured in Japan

First Printing, 1987
1 2 3 4 5 6 7 8 9 / 92 91 90 89 88 87

To my wife, Becky, my father, Louis,
and the cherished memory of my mother, Julia,
for their love and encouragement

Contents

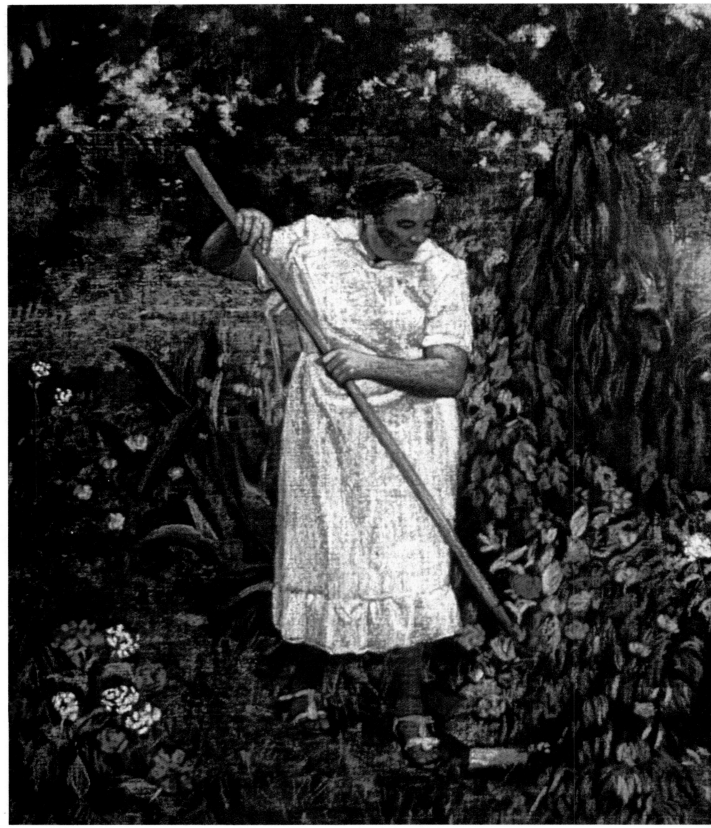

GERALDINE IN THE GARDEN, *muslin fabric board, 24″ × 30″ (61 × 76 cm). Collection Dr. and Mrs. Pat H. Gill.*

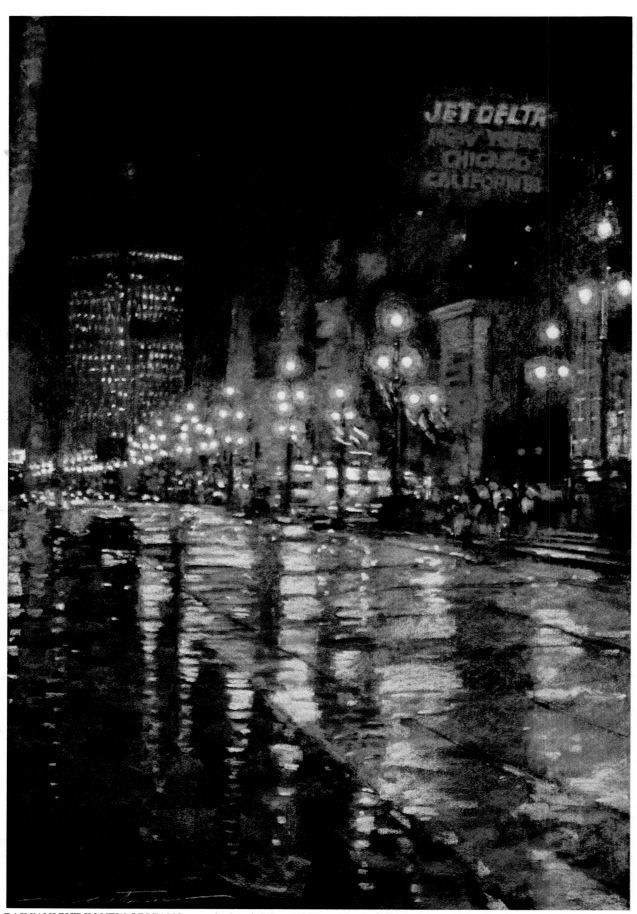

RAINY NIGHT IN NEW ORLEANS, *granular board, 28" × 19" (71 × 48 cm). Collection Mr. and Mrs. Frank Lauritzen.*

Introduction

Why would a contemporary artist choose to work in pastels? Although the medium has been around almost four centuries, in the hierarchy of artistic media it is generally placed near the bottom. Artists are intrigued by pastel, but skepticism of its permanence and ignorance of its advantages and potential prevent many from using it for serious artwork.

Both critics and writers are perplexed in attempts to define exactly what pastel is—or can do. Terminology is definitely a problem. Works made with pastels are variously described as having been done with colored crayons, colored chalks, or even colored charcoals. The pictures are called pastel drawings by some and pastel paintings by others. In reality, all these terms are partly correct. The reason pastel is so hard to define is that it is not like any other medium.

Pastel is capable of producing a wide range of drawing and painterly effects. The artist can draw fine detail, crosshatch or juxtapose linear strokes, blend, scumble, scrape, or even wet the work and paint into it with brushes. Velvety-soft, translucent darks and strong impasto lights are possible. In addition, pastel can be used on many surfaces and combined with other media to produce unlimited effects.

The artist has at his command a magnificent range of the most brilliant and purest colors of any medium. Freshness and luminosity can be achieved without the fear of dulling that is characteristic of mixing colors on a palette. In addition, pastels are convenient and easy to use. Little setting-up time is required; there are no tubes to squeeze, no paints to mix, no smelly solvents, and no brushes to clean. Moreover, the fact that pastel is dry permits the artist to leave his work and start again any time he chooses, and he is free of many of the technical problems and anxieties inherent to wet media, such as changes in color on drying. Pastel can be spontaneous, yet it is highly predictable. The artist can fine-tune a picture with an ease and accuracy unrivaled by other media.

When properly cared for, pastel is also among the most permanent of all media, despite an undeserved reputation of being fragile and impermanent. Paintings dating back to the early eighteenth century are still as bright and fresh as when they were painted. For example, at the Academy of Fine Arts on the Grand Canal in Venice, Italy, there are nine pastel portraits painted on paper that were executed in 1703 and 1704 by Rosalba Carriera, an early pioneer and master of the medium. In December 1983, Flora B. Giffuni, president of the Pastel Society of America, viewed these works, and she reports that despite the heat, humidity, and lack of air-conditioning, all the portraits are in perfect condition and have never needed restoration. This is certainly irrefutable proof of the permanence and durability of pastel.

This is not to say that pastel is perfect. It is probably more vulnerable to accidental damage and mold than most other media. Every medium has some inherent shortcoming that the good craftsman should understand thoroughly and compensate for if possible. Pastel, however, has the potential of being one of the most exciting media available to the artist.

The origins of pastel art are confused because both pastels and earlier chalk drawings are usually placed in the same category. Drawings were made in colored chalk as early as the fifteenth century in Italy, chiefly as studies for paintings. During the sixteenth century, the practice evolved into a separate art form when Jacopo Bassano and Frederico Barocci developed the technique in northern Italy. The German artist Hans Holbein the Younger and French artists Jean and François Clouet also did many colored chalk drawings during this period. It must be emphasized, however, that these works were done with natural chalks and earths that were cut into crayon shapes. True pastels are made from powdered pigments that are molded into crayon shapes. A proto-pastel technique was developed by the Italian artist Guido Reni (1575–

1642), but the invention or perfection of pastel is most often accredited to the German painter and chemist Johann Alexander Thiele (1685–1752).

Pastel first became popular as a portrait medium in the eighteenth century. The Venetian artist Rosalba Carriera (1675–1757) and the French artist Maurice Quentin de la Tour (1704–1788) gained fame throughout Europe for their charming pastel portraits. Both artists were master craftsmen who produced highly polished, flattering likenesses. They made little attempt to reveal the character of their subjects, however, nor was this expected or necessarily desired. Social status and attractive appearance were important to the royal and aristocratic patrons of the period. These early pastelists found that pastel, with its light tints and delicate touch, was ideally suited to painting the powdery coiffures and complexions that were in fashion. Ironically, these saccharine portraits, so admired in the eighteenth century, have diminished the popularity of the medium since then. Pastel became strongly associated with the superficiality of the period, and later generations of artists generally rejected its use for serious artwork.

Fortunately, a handful of intuitive artists were not deterred by the bad reputation pastel had gained. They employed it enthusiastically, and use of the medium continued to evolve.

Jean-Baptiste Siméon Chardin (1699–1779), the renowned realist oil painter, took up pastels in his old age. A master of color, he immediately realized the special qualities of pastel. Unlike his contemporaries who blended pastel extensively, Chardin applied it in visible strokes. To obtain gradations, he juxtaposed pure color in tightly woven patterns. Probably the first use of broken color in pastel, his work presaged the future direction of the medium.

Jean François Millet (1814–1875) continued the advancement begun by earlier pastelists and worked with the medium almost exclusively from 1865 to 1869. Rather than attempting to use pastel as though it were paint, he drew with it and let his tinted paper show through. The pastels, which varied from figure compositions to colorful landscapes, are some of Millet's finest works.

Of course, the culmination of the use of broken color in pastel came with Impressionism. Pastel's pure, brilliant hues and directness of application were in complete harmony with the methods and theories of the movement. Degas, Manet, Monet, Morisot, and Renoir all showed pastels in the Impressionist exhibitions.

Edgar Degas (1834–1917) is undoubtedly the artist most responsible for transforming pastel into a major medium. Pastel blossomed under his hand, and he developed exciting new techniques. He applied pastel in bold strokes and, by spraying heavily with fixative, was able to superimpose additional strokes in different colors, often at an angle to lower layers. The results were rich surfaces of sparkling color and paint quality of exceptional variety. Degas also combined pastel with other media such as gouache, watercolor, distemper, oil thinned with turpentine, and monotype. He worked with pastel throughout his career, and from around 1880 on, he used it for almost all his important works. It is in pastel, not oil, that Degas made his greatest contributions, and it is his pastels for which he is most noted.

Prior to Impressionism, pastel was limited almost exclusively to portraiture. With the advent of photography in the 1840s, pastel was employed even less. The art of pastel slumbered until 1870 when the Société des Pastellistes was founded in France and met with ready appreciation. Interest in pastel increased steadily, and in 1880 the Pastel Society of England was formed and has remained active to this day. Three of its outstanding members were the master pastelists Edward Stott (1855–1918), Professor Henry Tonks (1862–1937), and Sir George Clausen (1852–1944).

America was not far behind, and in 1882 the Society of American Painters in Pastel was formed to promote interest in pastel art and held its first exhibit in 1884. The second exhibition was not held until 1888, but was followed by two others in 1889 and 1890. Curiously, although the exhibits met with much critical acclaim, the group dispersed and never held another exhibition. The most noted participants in these exhibits were William Merritt Chase (1849–1916), Robert Blum (1857–1903), John Henry Twachtman (1853–1902), Julian Alden Weir (1852–1919), Childe Hassam (1859–1935), and Robert Reid (1862–1929).

The American painter Mary Cassatt (1845–1926) was influenced by Degas, who was her mentor and friend. She developed techniques similar to his, and pastels are among her most important works. She also participated in several of the Impressionist exhibitions.

Oddly enough, however, Degas did not influence other American pastelists at the time. In fact, he was hardly known in America in the early 1880s. Instead, Millet, Whistler, and the now relatively unknown Giuseppe de Nittis had a strong impact on the Americans and inspired them to pursue the medium.

The American expatriate James Abbott McNeill Whistler (1834–1903) was primarily an oil painter and etcher, but he also produced many small, exquisite pastel sketches. His method was to outline the main details of his subject in black crayon on tinted paper and then fill in with patches of color.

Giuseppe de Nittis (1846–1884) was born in Italy and had a brief but spectacularly successful career. His pastel portraits and street scenes received much public attention and acclaim. De Nittis's pastels are striking in their large size, strong color, and elaborate, ambitious compositions.

William Merritt Chase was probably the most innovative and proficient of all the American pastelists. He used pastel with a freshness and vitality rivaling that of any European master. Some of his pastels were very large, up to six feet high, and done on canvas. Like Degas, he often wet his pastel and worked it over with brushes. He apparently also used a lot of fixative between layers of pastel.

Although the Society of American Painters in Pastel was short-lived, it served its original purpose and pastel was recognized as a worthy medium—at least for a while. Sometime after the death of Chase in 1916, however, the medium once again fell into general disfavor. With the great wave of Abstract Expressionism and other nonrepresentational art in the 1940s, 1950s, and 1960s, pastel almost disappeared from public attention. Among the few die-hards of the period who received some recognition for pastel painting were Robert Brackman (1898–1980) and Robert Philipp (1895–1981). There also seemed to be a developing underground movement comprising a new generation of realist painters who embraced pastel.

Then in 1973 the National Arts Club of New York launched an exhibition for pastels only, the first held in the United States since 1890. Its spectacular success seemed to herald a new era— possibly even a modern pastel renaissance. The show was continued annually, and in 1975 the Pastel Society of America was officially formed. Thousands of artists have since discovered the medium as is evidenced by the many pastel societies that have sprung up around the country. Among the modern masters of the medium are such noted painters as Aaron Shikler, Burt Silverman, Harvey Dinnerstein, Daniel Greene, and Albert Handell.

Perhaps we all have a little of the evangelistic spirit in us. When we find something that is good and enriching, we want to spread the word. Many pastelists are like that about their medium. We feel we have been enlightened and have a duty to give other artists the good news.

I am convinced that pastels are not more widely used because artists are usually frustrated and discouraged in their attempts to use them or have simply never tried them. Either way, these artists are missing an exciting medium that is easy to use, versatile, and permanent.

Over my many years of teaching, I have introduced many students to pastels, and in return I have been rewarded by the enrichment of my own knowledge and a better understanding of the medium. Teaching has forced me to analyze pastel techniques very carefully and has enabled me to develop fundamental and systematic approaches to pastel. These approaches are not tied to any particular style of painting but are logical concepts aimed at achieving good paint quality, exciting textures, rich color, and maximum permanence.

My goal in presenting the information here is to ease the difficulties of learning a new medium for beginners and to offer fresh insights and ideas to artists already working in pastel. My sincere wish is that this book will encourage more artists to consider the medium for serious art work and will offer a better appreciation of pastels to anyone who admires pastel art.

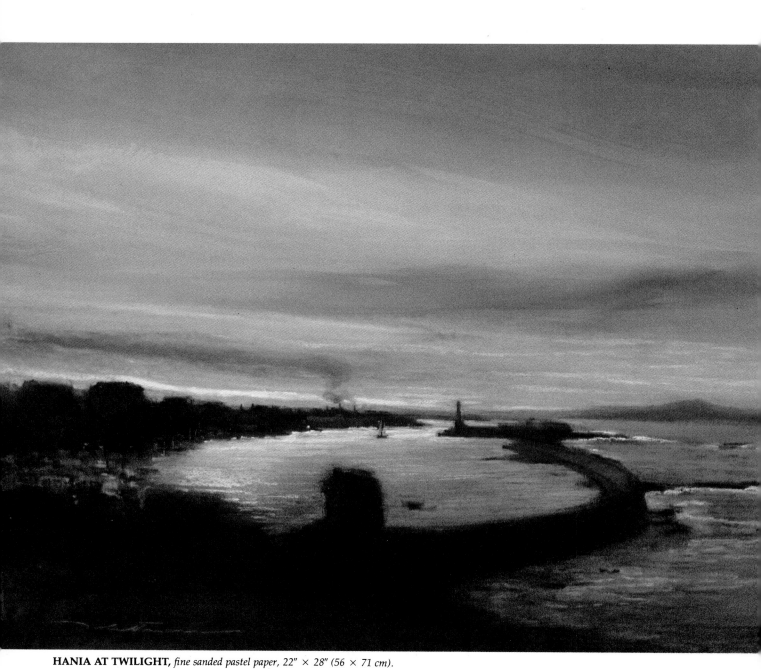

HANIA AT TWILIGHT, *fine sanded pastel paper, 22" × 28" (56 × 71 cm).*

CHAPTER ONE

Pastel Palette

Pastels are a type of crayons molded from a mixture of dry powdered pigment and binding solution. The word *pastel* is derived from the paste made by grinding the pigment and liquid binding solution together. Compared to other painting media, pastels are the simplest and purest. Only a very weak binding solution is employed that has no noticeable effect on the color of the pigment, and no additional medium is required. Pastel is as close as the artist can come to painting with pure color.

Pastels are made in several varieties and forms. They should never be confused with ordinary colored chalks, such as those used for schoolroom blackboards, which are nothing more than a limestone substance impregnated with dyes. Good-quality modern pastels are made from pure pigments that have a lasting richness and brilliance.

In purchasing pastels, it is generally a good idea to buy only colors that are identified as permanent pigments, such as burnt sienna, yellow ochre, ultramarine blue, and so on. *The Artist's Handbook of Materials and Techniques* by Ralph Mayer gives a complete list of these. This advice, however, may be difficult to follow. Pastels are made in hundreds of colors, and the manufacturers take many liberties in naming them. There are also inconsistencies; identical colors may have different names from brand to brand, and color combinations of various pigments are usually labeled only by hue, such as reddish violet, bluish violet, and so forth. Fortunately, the truly impermanent pigments have virtually been eliminated from the major pastel brands, and the relative permanence of each color is indicated by the makers.

Pastels are defined as being either soft or hard. The strength of the binder determines this property—the stronger it is, the harder the pastel. Soft pastels are by far the most useful and have superior brilliance, intensity, and paintlike qualities. They are indispensable for laying in large color areas and for building up heavy pigment. Hard pastels are primarily useful for refining and drawing purposes.

Soft pastels are usually made in chubby, round shapes and hard pastels in narrow, square shapes. Hard pastels can be sharpened to a point, and small metal holders are available to elongate them. Pastel pencils are another type of hard pastels that are especially suited for drawing fine lines and detail.

Oil pastels are a different medium altogether. They contain an oil and wax binder that produces a slick, waxy paint film. They are incompatible with soft pastels and not recommended for the techniques described in this book.

PALETTE

Pastels cannot be intermixed on a palette to make new colors in the same way as wet paints—so it is necessary to have many more individual colors. A large selection of pastels, however, does not guarantee good color—and may even be a hindrance. An imaginative artist with a handful of pastels can create a vibrant color composition, while a less inventive artist may only manage mud out of an elaborate set of colors. Pastels can be intermixed on the painting to create new colors by blending, layering, and juxtaposing. Consequently, you can do well with a lot fewer colors than you may think you need.

I personally own about five or six hundred different pastels—which, of course, seems like a total contradiction of what I have just stated. The problem is that I have been collecting them for years and years. They are the result of trying new

brands, making my own, and occasionally buying on impulse. Once I discovered that I was using the same colors over and over and simply replacing them—leaving most of the others to collect dust—I reorganized my palette and greatly condensed it, taking out numerous duplicates and colors I seldom, if ever, used. My palette of soft pastels now consists primarily of the following pure colors, with at least one tint and one shade of each color—about 120 pastels altogether. I have tried to list the various names of identical or very similar colors that are interchangeable.

White
Lemon yellow
Cadmium or sunproof yellow light
Cadmium or sunproof yellow deep
Yellow ochre
Raw sienna or brown ochre
Cadmium or sunproof orange
Cadmium or permanent red light
Cadmium or permanent red deep
Alizarin crimson, madder lake, or rose
 madder
Burnt sienna
Indian or English red
Burnt green earth
Burnt umber
Raw umber or sepia
Caput mortuum deep
Mars violet
Violet
Ultramarine blue
Cobalt blue
Phthalo (thalo) or greenish blue
Prussian (Milori) blue
Cerulean or bluish green
Phthalo (thalo) or leaf green
Moss or permanent green
Verona green (green earth)
Chromium green oxide (oxide of chromium)
Olive green
Bluish gray
Neutral gray
Black

It is especially important in a pastel palette to have the darkest shade you can find of burnt umber, raw umber or sepia, caput mortuum deep, Verona green, olive green, bluish gray, and neutral gray, and the lightest tint available of lemon yellow, cadmium or sunproof yellow light, and

yellow ochre. To identify these, it is helpful to understand the way soft pastels are labeled. Each manufacturer starts with a crayon of pure color and then makes lighter and darker variations. Grumbacher, for instance, labels its pastels with a system of letters behind the number of each color. The letter D indicates a crayon of 100 percent pure color. Shades are made by adding black to the color; A indicates 40 percent black added (darkest), and C indicates 15 percent black added. Tints are made by adding white; F indicates 15 percent white added; H, 40 percent; K, 60 percent; and M, 80 percent (lightest). Other manufacturers have similar systems.

There are many brands of pastels on the market today. Grumbacher and Rembrandt, which are probably the best known, are fine-quality, moderately priced pastels. Among the higher-priced, premium-quality pastels, Girault and Sennelier are excellent (although I wish they were larger), but my personal favorite is Schmincke. These German-made pastels have all the qualities I look for—they are large, extra soft, and exceptionally rich in color. Other good pastels are also available that you might want to try. Test several brands, if you can, to see which you like best. Then I recommend you buy a set of about ninety colors and supplement them as the need arises.

In addition to soft pastels, I also suggest the following drawing materials and hard pastels for your palette. Although I have many others, these are the ones I find the most useful and take with me on painting trips.

Vine charcoal
Extra soft charcoal pencil
Conté sanguine drawing pencil
Conté sepia drawing pencil
Conté sanguine crayon
Conté sepia crayon

PASTEL PENCILS

Conté #47	Naples yellow
Conté #30	Mineral green
Conté #51	Gray green
Conté #53	Payne's gray
Conté #33	Dark gray
Conté #42	Sepia
Conté #54	Natural umber
Conté #32	Umber
Othello #59	Bistre

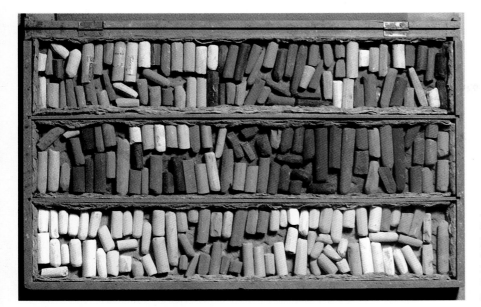

Master palette. *This box contains the soft pastel colors I use at least 90 percent of the time. The pastels are broken into small pieces and the paper removed from them so that the sides of the pastels can be used to apply wide strokes of color.*

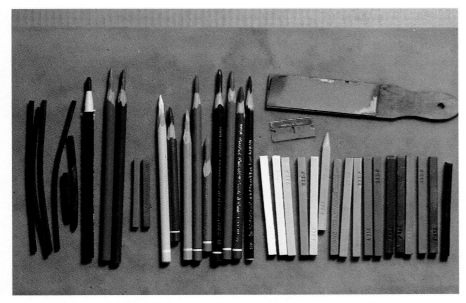

Drawing materials and hard pastels. *This is the selection of charcoal, Conté pencils and crayons, pastel pencils, and Nupastels (hard pastels) that I recommend as a basic supplement to soft pastels. The best way to sharpen the pencils is to remove about 1/2" of wood from the tip with a razor blade, then file the pastel lead to a point with a sandpaper pad.*

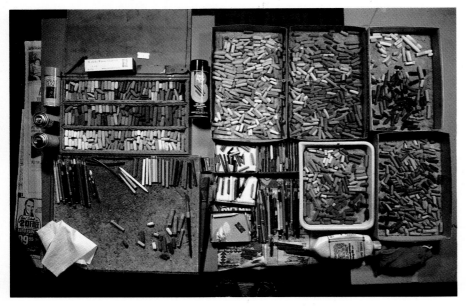

Worktable. *This is the way my table is usually set up when I am working on a pastel. My working palette—the tray where I place the colors I am using at the time—sits closest to me, at the bottom left. Above it is my master palette, and to the right are boxes of extra colors.*

NUPASTELS (hard pastels)

#277. Ivory
#276. Flesh pink
#243. Light ochre
#233. Raw sienna
#376. Peach
#296. Salmon pink
#266. Pale vermilion
#204. Sandalwood
#333. Titian brown
#213. Sanguine
#263. Indian red
#223. Burnt umber
#298. Bottle green
#248. Olive green
#405. Blue haze
#259. Cold deep gray
#229. Black

Palette Arrangement

A pastel palette must allow you to find the colors you want easily, keep the colors as clean as possible, and keep the colors in order. Many systems, simple and elaborate, have been devised over the years. Some artists place each crayon in its original space in their sets, but this is very time-consuming and tends to complicate use of the pastels. Furthermore, as the pastels are broken in pieces and new colors are added, the system eventually leads to complete disarray. Some artists have no system at all—they simply throw all their pastels together in one big box. Soon the colors are so filthy that it is impossible to tell what they have.

The arrangement of the colors on my palette has remained fairly constant over the years, but the size of my pastel box has fluctuated quite a lot. I started with a small wooden box about 11" x 18" (30 x 40 cm), which originally held a set of ninety Grumbacher pastels. Gradually that evolved into a tray about 30" x 36" (76 x 91 cm), but I found it increasingly difficult to keep the colors clean and in order in a box that large. So I have gone back to my original small box and keep in it the colors I use most frequently. It is easy to manage and ideal to carry along on painting trips.

The box is divided into three sections and the colors arranged by hue in a transition somewhat like that of a color wheel. From left to right, the bottom row has white, yellows, brown-yellows, oranges, and pinks; the middle row has blues, violets, brown-violets, browns, brown-reds, and reds; the top row has blue-greens, greens, brown-greens, grays, and black. It is simple to find and organize colors with this arrangement, and the colors stay relatively clean because they do not rub against completely unrelated colors. I also vacuum the pastels routinely (with a piece of fiberglass screen over the suction hose) and clean them with a paper towel after use.

I keep the majority of my extra pastels in five cardboard boxes about 10" x 15" each (25 x 38 cm) that are also divided into color categories. The first box has yellows, brown-yellows, and oranges; the second has pinks, reds, brown-reds, browns, brown-violets, and violets; the third has blues; the fourth has blue-greens, greens, and brown-greens; and the fifth has grays, blacks, and whites. The boxes can be compactly stacked for storage, but I usually set them out in case I am looking for a color not in my master box or for a color replacement. I also have sets of Schmincke and Rembrandt pastels from which I can take colors when needed.

When working on a painting, it is important to keep the pastels being used separate from the pastel boxes. That way, you avoid having to search for the same colors over and over and it is easier to keep the boxes in order. I use a 16" x 20" (41 x 51 cm) plastic tray for this purpose. Before beginning a pastel, I select the major colors I will use and set them out on this "working" palette—and do not put them back until the painting is finished. This is also a wonderful way of visualizing a color scheme in advance.

All my pastel boxes are lined with foam rubber, which cushions the crayons and collects much of the dust from them. In a novel, alternative method I have heard of, the bottom of the pastel box is replaced with screen wire and the box is set over a tray of water. Pastel dust falls into water and the tray can be removed and emptied. Theoretically, this eliminates the need to vacuum the pastels and keeps them cleaner.

An organized palette is essential to every medium. Whistler told his students that the palette itself should present a beautiful appearance. He would often look, not at the students' pictures, but at their palettes. "If you cannot manage your palette," he asked, "how are you going to manage your canvas?" Take the time to organize a beautiful palette, and you may be rewarded with beautiful pictures.

HANDMADE PASTEL CRAYONS

Making your own pastels is time-consuming and messy work—not suitable or advisable for everyone. I recommend it only to serious artists or

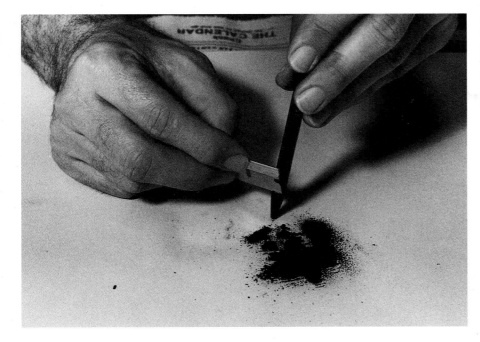

students who are committed to pastel painting. Anyone else would probably not appreciate the subtle differences and advantages of handmade pastels. For most artists, the commercial pastels are perfectly adequate, but for artists seeking the best materials possible, handmade pastels are well worth the effort.

I began experimenting with pastel making because I was dissatisfied with the color selections available to me and tired of the inconvenience of running to the art store whenever I ran out of a color. I also felt that the experience of preparing my own pastels would give me a better understanding of the medium, and there was always a chance that I might make a pastel more to my liking.

As it turned out, the experience more than fulfilled my expectations, and I have become a strong advocate of pastel making. The primary advantages of homemade pastels are:

Unlimited color range. My biggest complaint with commercial pastels has always been the lack of very dark tones. There is too wide a gap between pure black and the dark greens, browns, and the like. By making your own, you can make colors as dark as you like. You are in complete control. I have also found that I can make colors that are more useful. For instance, if I start out with a basic flesh pink tone, I can mix the lighter and darker gradations of it to resemble actual color changes in flesh tones. Rather than adding only white for the light tints, which alone tends to make the color pasty, I also add a little yellow ochre. For the dark shades, I add a little alizarin crimson and perhaps ultramarine blue along with the black, which alone makes the color muddy. Basically, then, rather than making lights and darks different only in value and saturation, I also give them a temperature change—making lights warm and shadows cool—which is a more natural gradation.

Maximum permanence and purity. You can ensure both qualities by insisting on the best ingredients available. This means using only proven permanent pigments, a safe binder, and a preservative to prevent mold. Maximum brilliance and richness are possible because you can produce pastel colors of full chromatic strength, unweakened by fillers.

Maximum softness and brilliance. Commercial pastels have to be made hard enough to withstand breakage during shipping and handling. Although they eventually need to be broken anyway, buyers do not want broken merchandise. When you make them for yourself, this is not a concern. My pastels are as soft as they can possibly be without falling apart. The sticks are thus more fragile than commercial pastels. They break more easily and sometimes even crumble a little under heavy pressure. The chief advantage of softer crayons is that they make thick layers of color easier to apply. The pastels are more yielding and do not dig into the underlayers as much as harder crayons. The resulting paint quality is richer, and the colors are more intense. Light colors can be applied with real impasto effects and are especially brilliant.

Economy. It is possible to make high-quality pastels at a fraction of the cost of the ready-made product. The initial investment is about the same as the price of a large set of commercial pastels, but the materials will make many hundreds of pastels and hardly ever need replacement. You can also purchase the materials gradually, starting with the colors you need most.

Pride in craftsmanship. This is the most intangible feature of pastel making, but there is a definite satisfaction that comes from making your own materials. Centuries ago, artists were intimately acquainted with their craft because they made almost all their painting materials by hand. They understood the performance and limitations of their materials much better than modern artists who have become accustomed to buying everything ready made.

Basic Materials and Sources

Dry pigments

Binder: methyl cellulose (recommended) or gum tragacanth

Preservative: sodium orthophenyl phenate (recommended) or beta naphthol

Plate glass slab about 15" x 18" (38 x 46 cm) or larger

Flexible spatula or putty knife 3" to 4" (8 to 10 cm) wide and palette knife

Glass muller (optional)

Mortar and pestle made of glass or porcelain (optional)

Electric mixer

Glass bottles, measuring cup, and measuring spoons

Newspaper, torn into sheets about 7" x 11" (18 x 28 cm)

Water mister, buckets, and sponges

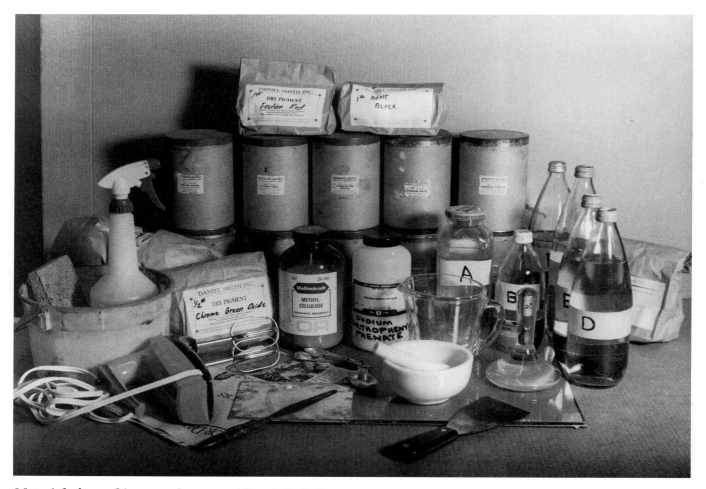

Materials for making pastel crayons. *These include dry pigments, a binder, preservative, labeled bottles of solution, and assorted equipment.*

It is easy to spend more money than necessary on dry pigments. Always buy them by the pound, half pound, or quarter pound (½ kg to 100 g) from a major supplier. Avoid the small 30 mL jars of pigment sold in most art stores. You will probably pay more for them than for a pound of the same pigment from a supplier. Start by purchasing the major pigments and gradually increase your palette as the need arises. Keep in mind that one pigment may duplicate others and save you the expense of acquiring every available color. For instance, burnt sienna mixed with black is essentially equivalent to burnt umber. Chromium green oxide mixed with white reproduces terre verte. The extremely expensive cerulean blue can be simulated with a mixture of phthalo or Prussian blue, white, and a dab of yellow ochre. Along the same line, the relatively inexpensive Prussian blue can duplicate most of the color mixtures the much more expensive phthalo blue can make.

You may be able to order the pigment and other supplies through your local art store, a mail order company, or direct from the manufacturer. I recommend finding at least two sources and comparing prices. The chemicals can be purchased only from a chemical or scientific supply company. They might be available through a pharmacy, but probably at a premium price. Only very small quantities of the chemicals are required, teaspoons and tablespoons, but unfortunately they are usually sold only by the pound or similar amounts. Try to find someone with whom you can share this cost. Some chemical supply companies handle dry pigments at reasonable prices. In requesting prices, give the chemical name of the pigment as well as its trade name—for example, viridian is hydrated chromium hydroxide.

Suppliers I have found to be reasonable and reliable are City Chemical Corporation, Daniel Smith, New York Central Art Supply, and Tricon Colors (see List of Suppliers, page 139). Most other supplies can be found at hardware stores.

Pigments

All the permanent pigments used in watercolor and tempera colors can be used for pastels. However, lead pigments such as flake white, Cremnitz white, and Naples yellow, which are commonly used in oils, must *absolutely* be avoided for a pastel palette. Both acute and chronic inhalation or ingestion of these and a few other fairly obsolete pigments like arsenical cobalt violet, minium, chrome yellow and emerald green can be deadly poisonous! Because pastel is in a dry form, the pigment is especially susceptible to being inhaled. Several pigments that are generally included in pastel palettes—such as the umbers, phthalos, cadmiums, and vermilion—are also highly toxic over the long term, so precautions must be taken with *all* pigments. For information about the toxicity of specific pigments, *Artist Beware* by Michael McCann is an excellent reference. You may be able to substitute nontoxic pigments for some of the more dangerous ones.

The main white pigment used in making pastels is precipitated chalk, which is *artificially* prepared calcium carbonate in its whitest and purest form. It is not to be confused with common chalk, or whiting, which is *native* calcium carbonate, is not as white, and has insufficient covering power. Even so, precipitated chalk is a very weak white, and I recommend a mixture by volume of 25 percent titanium white and 75 percent chalk. For the lightest shades you may use up to 100 percent titanium white. Titanium is a very opaque, heavy, brilliant white that barely darkens even under heavy fixing, but it is too opaque and overpowering for general mixing. Zinc white may be used like titanium, perhaps in a greater percentage since it is not as opaque. Without the addition of titanium or zinc white, tremendous amounts of precipitated chalk would have to be mixed with colors to achieve strong lights. (Chalk, being the least expensive pigment, is used alone in cheaper grades of pastel.) Since the pure colors would be much more extended with chalk, the colors would possibly be more susceptible to fading.

Binding Solutions

During the development of pastel, many unlikely substances were used for binders, such as strained oatmeal gruel, honey, starch, crystalized sugar, skim milk, soapy water, and one nineteenth-century recipe even called for brandy and spirits of wine. Chiefly, however, gum tragacanth has been the most acceptable and widely used binder. The inherent problem with these materials is that they are attractive to microflora, or mold development. Methyl cellulose (a neutral pH polyvinyl emulsion), which is less subject to mold, is now recommended as a modern substitute. By good fortune, it is also much less expensive than gum tragacanth.

Beta naphthol has been the traditional preservative or mold preventative used in the binding solutions, but it is only slightly soluble in hot water and discolors the solution. I prefer sodium orthophenyl phenate, which dissolves easily in

lukewarm water and is colorless. All of these chemicals should be used in a powdered form. They are also sold in granules, which must be ground into a powder using a mortar and pestle or similar instrument.

Binding solutions are needed in various strengths because of the differing properties of the pigments. Proportions for the following solutions, as well as the directions for mixing, are essentially based on Ralph Mayer's instructions, with a few significant alterations.

PRESERVATIVE SOLUTION
Water (lukewarm): *5 quarts (4³/₄ L)*
Sodium orthophenyl phenate (or beta naphthol): *2 level teaspoons*

A SOLUTION
Preservative solution: *48 fluid ounces (1¹/₂ L)*
Methyl cellulose (or gum tragacanth): *2 level tablespoons*

B SOLUTION
A solution: *8 fluid ounces (¹/₄ L)*
Preservative solution: *8 fluid ounces*

C SOLUTION
A solution: *8 fluid ounces*
Preservative solution: *24 fluid ounces (³/₄ L)*

D SOLUTION
A solution: *4 fluid ounces (1 dL)*
Preservative solution: *24 fluid ounces*

E SOLUTION
A solution: *2 fluid ounces (¹/₂ dL)*
Preservative solution: *24 fluid ounces*

Directions
Make up the preservative solution by adding the preservative to lukewarm water and mixing thoroughly. If you are using beta naphthol, dissolve as much of it as possible in a cup of hot water before adding the remaining water. Only a very low concentration is required, so do not be concerned about any that settles to the bottom. Next, make the A solution by adding the binder to the preservative solution in a mixing bowl and letting it soak about twenty-four hours in a warm place while a gel forms on top. Then beat the mixture with an electric mixer until it becomes homogeneous. It may be necessary to repeat this step several times at hourly intervals to thoroughly dissolve the gel. With methyl cellulose, some traces of gel may still remain but will eventually dissolve in a few days. It is not necessary to wait to make the other solutions as long as you stir the A solution well

before measuring. A large amount of foam may result from the high-speed mixing. Be careful in preparing the other solutions to measure the liquid only, not the foam. Store the solutions in well-capped bottles and label them.

The strength of the binding solution needed to achieve the proper degree of softness for the crayons depends on the pigment being held. Every dry pigment has its own nature. For example, cadmium yellow ground in the *A* solution has just the right softness, but yellow ochre ground in the same solution would make a crayon so hard that it would be impossible to apply color with it. There does not seem to be any real logic to determining which strength binder each pigment requires. Pigments may also vary from one source to another, so the only way to accurately determine the proper binding solution is to make your own test. Each pigment I have ground has worked well with one of the listed binding solutions, but you may need to adjust the strength of some of the solutions to suit your own pigment. Be sure to keep an accurate record of any changes.

As a general guideline, I have achieved good results with the following combinations, utilizing methyl cellulose as the binder:

A solution:	*Cadmium red, cadmium yellow, cadmium orange, alizarin crimson*
B solution:	*Cerulean blue*
C solution:	*Precipitated chalk, titanium white, zinc white, ivory black, viridian, phthalo blue, ultramarine blue, cobalt blue, Mars violet, chromium green oxide*
D solution:	*Raw sienna, yellow ochre, Indian red, Milori (Prussian) blue*
E solution:	*Burnt umber, raw umber*
Preservation solution:	*Burnt sienna, green earth (terre verte)*

Start by measuring out a small amount of pigment, perhaps a heaping teaspoonful, on a glass slab. Gradually add a little of the suggested binding solution and mix with a palette knife. With the putty knife, grind it into a smooth paste about the consistency of stiff putty. Roll it in your hands into a little plump crayon. Do this for each pigment and set the crayons in an oven at 150°F for a few hours to speed up drying. When dry, test them for the desired softness. If the color takes easily to a surface, the binder is right, but if a crayon crum-

bles during drying or breaks under slight pressure, it needs a stronger binder. If the color does not take easily to a surface, the crayon is too hard and probably requires a weaker binder. The exceptions may be the earth colors. Green earth (terre verte) and burnt sienna in particular tend to dry too hard even when ground in plain water. When they are mixed with a small amount of chalk or black pigment, however, they become very soft and functional. Keep making the little crayons until you determine the best binding solution for each pigment, and record this information.

In grinding the various pigments, you will find some more difficult than others. For instance, alizarin crimson is so extremely light in weight that it is very difficult to disperse in the solution and you have to be very persistent. Ultramarine blue seems impossible to get to the right consistency—it is either too dry or too sticky—but adding a little chalk will stabilize it. Phthalo blue is so potent that it stains everything it touches, and I therefore recommend grinding it last.

You are now prepared to make an unlimited number of pastel crayons to suit your taste. To become better acquainted with the way the pigments behave, I suggest you begin by working with one color at a time and produce a series of gradations by adding white and black. Always start by grinding the white and lighter colors first on the slab. It is a good idea to have a separate slab for the white so that no other pigment accidentally discolors it. In any case, clean the slab thoroughly with water and sponges after grinding each color.

Measure out about 6 ounces by volume (1¾ dL) of the combination of 25 percent titanium white and 75 percent precipitated chalk (premix these dry and keep in a separate container). Add a little of solution C and mix with a palette knife. Gradually add more solution and mix with a putty knife until a paste is made. If you have a muller, begin to grind the paste with it in a circular motion until it is perfectly smooth and the consistency of stiff putty. You can also accomplish this with the putty knife alone, but it takes longer. Put a little of the paste in your hands and try to roll it into a ball. If it is very sticky, grind slightly more pigment into the paste. If it is too dry and does not shape easily, add a little more solution. When the paste is the right consistency, set it aside to serve as your stock. If it sits for any length of time, mist it with water occasionally to keep it from drying out.

Now measure out about 3 ounces by volume (¾ dL) of one of the colored pigments and repeat the procedure with the designated binding solution.

Divide the color paste into thirds and set two-thirds aside. Take one-third and roll it between your hands like dough into a ball, then gradually into a cylindrical shape with tapered ends. Place the dough on a sheet of newspaper and roll it with a small piece of cardboard about 4″ × 6″ (9 × 13 cm) covered with a piece of the newspaper into a smooth crayon. This amount of dough makes a crayon about twice the size of the commercial product. Set the crayon carefully on a cookie sheet covered with foil or wax paper. If it gets bent in moving, straighten it between two pieces of cardboard. It need not be perfectly uniform, however, and you can make it any size.

To make the light gradations, take the second third of the color paste and mix it with an equal volume of white paste. Grind it until there are no streaks left. (If the mixture has begun to dry out, mist it with water until the right consistency is achieved. Do not add more binding solution.) Divide this mixture and make another crayon from half of it. Again add an equal volume of white to the remaining half and make another crayon. In this way you can create an unlimited number of equal gradations of one color. The first crayon is 100 percent chromatic strength, the second 50 percent strength, the third 25 percent strength, and so on. Continue making as many light gradations as you like.

To make the darker gradations or shades, follow the same procedure as for the lights. First make a black stock, then add it in various amounts to the remaining third of the color paste. You may find that adding an equal amount of black to the color is too severe. In this case, try adding 50 percent black for each darker shade.

Repeat this entire process for each color pigment until you have a complete set of tints and shades. By then you probably will be fairly familiar with the nature of each pigment and ready for more creative color mixing. To mix two or more colors together, first grind them into a paste separately with the designated solutions. Then mix the different pastes together as you would oil paints until there are no streaks. Make gradations of these new colors with black and white or with the addition of other colors.

When drying the crayons in the oven, be careful not to bake them. Set the temperature at about 150°F and keep the pastels in for only an hour or two at most. They should feel slightly damp when removed. Then set them aside to finish drying naturally. If left in the oven too long, they might break into pieces.

PASTEL MAKING DIRECTIONS

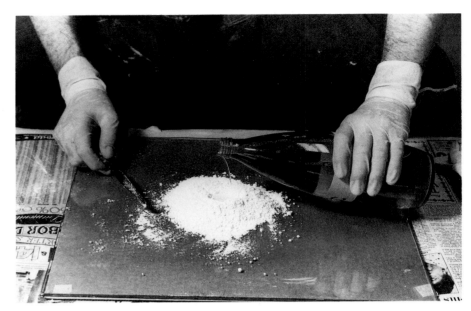

Step 1. *Start by grinding the white pigment. Measure out about 6 ounces by volume (1³/₄ dL) of the combination of 25 percent titanium white and 75 percent precipitated chalk. Add a little of solution C and mix with a palette knife.*

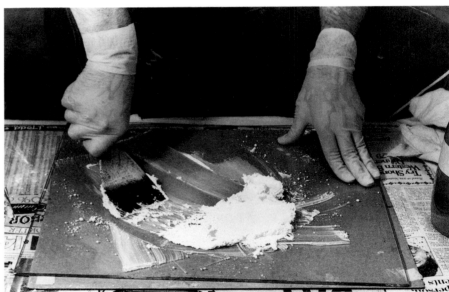

Step 2. *Gradually add more solution and mix with a putty knife until a paste is formed.*

Step 3. *If you have a muller, begin to grind the paste in a circular motion until it is perfectly smooth and the consistency of putty. Then set it aside to serve as the white stock.*

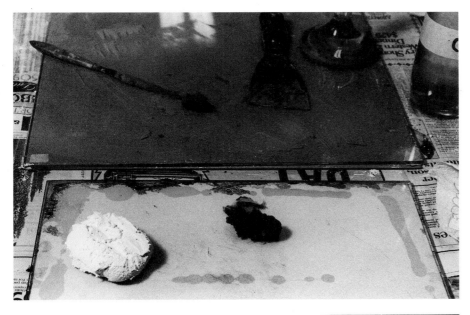

Step 4. *Measure out about 3 ounces by volume (³/4 dL) of one of the colored pigments and repeat the grinding procedure with the designated binding solution. Then set aside about two-thirds of the paste along with your white stock for later use.*

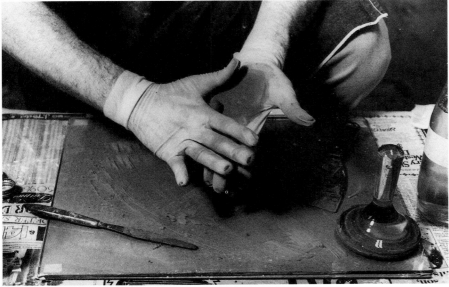

Step 5. *Take the remainder of the color paste and roll it between your hands like dough, into a ball.*

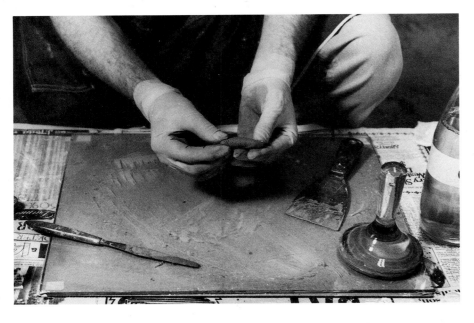

Step 6. *Then gradually roll it into a cylindrical shape and taper the ends with your fingers.*

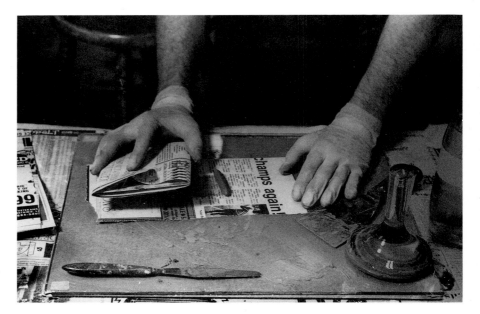

Step 7. *Place the paste on a sheet of newspaper and roll it (with a small piece of cardboard covered with newspaper) into a smooth crayon. Then carefully set it aside to dry.*

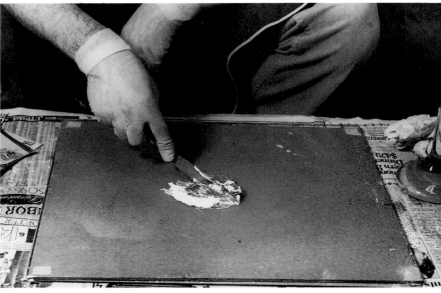

Step 8. *To make light gradations, take part of the color paste that was set aside and mix with an equal volume of white paste. Grind until there are no streaks left and roll into another crayon. An unlimited number of gradations of one color can be created by adding larger amounts of white for tints and various amounts of black for shades.*

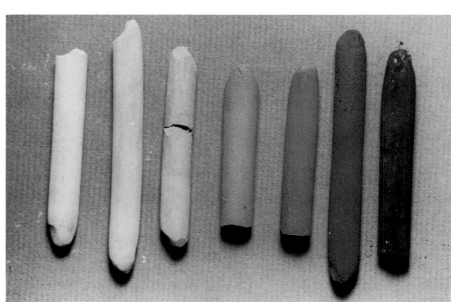

Color series. *This shows a completed series of tints and shades made from one pigment. The pastel in the center is made from the pure pigment and the value changes in the others are produced by the addition of white or black. I usually make the crayons about twice the size of commercial pastels, then break them into the sizes I need.*

Recycling Commercial Pastels

Even if you do not want to get involved in making pastels from scratch, you might like to make new colors from commercial pastels. For example, if you need a darker green, you can pulverize together half a black crayon and half a green crayon using a mortar and pestle. Make a paste from the powder by adding a little rubbing alcohol (it dissolves the glue and evaporates faster than water) and roll it into a new crayon. With this method you can make almost any color you want.

If you hate to waste anything, save your pastel shavings, crumbled pastels, and pieces too small to use anymore. Also carefully sweep the pastel dust from the easel ledge and save it. When enough has accumulated, grind it all back into a powder, then make new crayons as described above. You will be amazed at the useful grays and browns you can create.

HEALTH PRECAUTIONS

Although the most dangerous pigments have been eliminated from the pastel palette, there are still potential hazards in making and using pastels—so precautions should be taken.

When grinding dry pigments, wear a dust mask or respirator, and do not eat, drink, or smoke in the studio. Wash your hands carefully after work and wear plastic gloves when rolling the pastel paste in your hands. Pick up pigment powders with a wet paper towel or vacuum cleaner.

When working on a pastel painting, place it upright so the pastel dust falls gently away from the picture. Tap it from the back to dislodge any additional loose powder. *Do not* blow dust from the picture—which will cause the dust to become airborne and inhaled. Routinely vacuum and clean the studio to keep dust to a minimum. Take careful personal hygiene precautions to avoid ingestion of pastel dust. Use a protective hand cream *before* you begin work. I especially like #11 Up Front Cream Protective, available through Daniel Smith, Inc. (see List of Suppliers).

Furthermore, I recommend reading *Artist Beware* by Michael McCann, which gives more detailed information about health precautions.

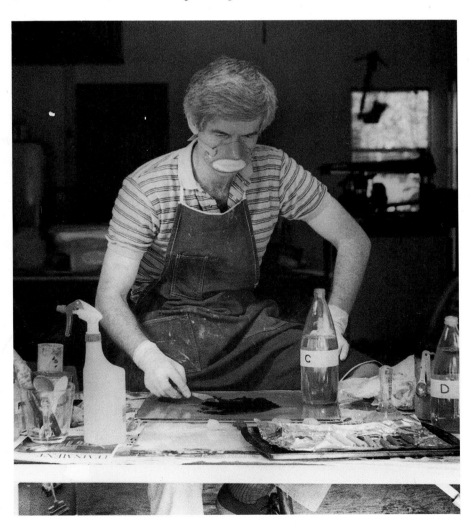

Health precautions. *Dry pigment is a very light powder that is easily dispersed in the air. To avoid inhaling it, I wear a dust mask while grinding the pigment. I also wear surgical gloves to protect my hands from staining and the danger of contact with the pigment.*

CHAPTER TWO

Pastel Grounds

The material on which pastel is executed has two parts—the ground or actual surface that has a texture (tooth) and the support, which is the foundation, backing, or carrier of the surface.

The ground and support are often one and the same, as is the case with pastel paper, which has a texture incorporated into its surface. Some pastel papers, however, are fragile and must be mounted on a stiff support. Grounds can also be painted on a support to impart a texture.

NECESSARY PROPERTIES

Tooth
Pastels require an abrasive surface or tooth to file away the pigment and hold on to it. The tooth is made up of peaks and valleys of various sizes. The finer the tooth, the quicker the valleys fill in and the surface becomes smooth. Once the surface becomes smooth, it is very difficult to apply additional pigment because the crayons slide across it. A rougher tooth takes longer to fill in and therefore can hold more pigment.

The surface texture is an integral part of any pastel technique because each ground imparts its own character on the finished pastel. Basically there are four types of surfaces used for pastel:

Napped. These soft furry surfaces, such as velvet, felt, velour, suede, and papers flocked with powdered cloth, are the least desirable of the various grounds.

Fibrous. The most commonly used grounds, including most papers and some other materials, these surfaces may be embossed with a pattern or display the natural grain of the materials' fibers.

Granular. Prepared with finely pulverized pumice, quartz, marble, or other stones glued to the surface, these grounds have a grainy, sandpaper-like texture.

Webbed. Fabrics such as canvas and muslin, which have an interlacing structure, webbed grounds also include boards and papers with simulated webbed patterns.

Permanence and Durability
In fine art *permanence* means using materials that resist deterioration over long periods of time. For example, rough newsprint paper produces an interesting pastel stroke but is unsuitable for serious work. In a relatively short time it will yellow badly and crumble. Most quality papers are made of 100 percent rag or contain a high percentage of rag. With proper care they can last as long as a fine linen canvas. Papers made primarily of wood pulp are not as permanent because they are manufactured with large amounts of bleach and other chemicals that cause premature deterioration. Thickness is an important factor in the durability of pastel papers. Thin papers are fragile and cannot endure much manipulation or abuse. When framed, they may buckle and fall against the inside of the glass. To be made durable, they must be mounted on a rigid board. The same advice also applies to canvas and fabrics.

Napped surfaces such as velvet and velour are relatively permanent, but their soft textures do not hold pigment well and the slightest vibration can dislodge it from the surface. Although they are fairly popular, they are not really suitable for pastel painting. Several companies produce velour-flocked papers and boards. They simulate a velvet surface and have a soft hazy effect when drawn upon with pastel. Although I do not recommend this surface, I have experimented with it and have been surprised by the amount of pigment it can hold. If you must use a napped texture, the paper is probably the best choice.

Pastel can be painted on many interesting materials, but permanence and durability must be the foremost considerations.

READY-MADE GROUNDS

Pastel and Charcoal Papers

The most popular pastel paper is Canson Mi-Teintes. It has excellent strength, is made of 66 percent rag, and is neutral pH. It is sold in sheets 19½" x 25½" (50 x 65 cm) and in rolls 11 yards long by 51" wide (10 m x 130 cm). Sheets cut from the roll larger than 19" x 25" should be mounted on a rigid board for support. A beautiful variety of thirty-three colorfast shades is available. The texture of the paper varies on each side. The smoother side has an interesting fibrous tooth, while the other side has an embossed mechanical pattern that is rather monotonous.

Canson Ingres and Strathmore charcoal papers have a traditional laid pattern of close thin lines. They are made of 100 percent cotton fiber and come in 19" x 25" sheets. The Strathmore paper is available in fifteen colors. I am particularly fond of the velvet and storm grays for figure drawing and sketching with a limited palette. For full-color work it is better to have the paper mounted because it is fairly thin. Fabriano also makes an Ingres charcoal and pastel paper with a laid pattern. It comes in 27½" x 39" (70 x 100 cm) sheets of 70-pound and 124-pound weights.

Watercolor Papers and Boards

These high-quality papers have been largely neglected by pastel artists. They are made by many companies in a wide variety of weights and textures. Arches cold-pressed, 140-pound weight has always been my favorite. It is a very strong 100 percent rag paper that can take a lot of beating. Sheets and boards 22" x 30" (56 x 76 cm) are standard, but 25½" x 40" (65 x 100 cm) sheets and large rolls are also available. One side of the paper has an interesting grainy texture that can hold a lot of pastel. The other side is similar to the texture of blotting paper, and I usually roughen it with a coarse sandpaper. Both sides produce good results—and if a painting fails, you can turn it over and use the other side with no problem.

If you plan to underpaint with watercolor or acrylics, I suggest stretching the paper in advance to prevent buckling. With an extra-heavy paper like 300-pound or 400-pound weight, this may not be necessary. To stretch the paper, soak it in a tub of water for several minutes. Then lay it on a sheet of plywood and put staples about 2" apart around the edges, or attach it with gum tape about ½"

from the edges. Some artists simply moisten the paper with a sponge and attach it to the board, but the paper may still buckle somewhat.

Crescent and Strathmore make an extra-heavy watercolor board surfaced with 100 percent rag paper. Available in 30" x 40" (76 x 100 cm) sheets, it is good for large paintings. The cold-pressed surface is again recommended. Crescent also makes a high-rag-content, multipurpose illustration board called Lin-tex, which has a simulated linen surface that produces interesting results.

If you are a watercolorist, you probably have a bundle of failures and near misses hidden in a corner somewhere. Try turning them into pastel paintings—an overworked watercolor makes a perfect underpainting.

Museum Rag Board

This high-quality 100 percent rag paper is manufactured by several companies in 32" x 40" (80 x 100 cm) and 40" x 60" (100 x 150 cm) sheets in 2-ply and 4-ply thicknesses. Color selection once was limited to white and cream, but the Rising Company now offers several brown and gray shades as well. The paper can also be underpainted or toned with water-based paints, but it may need to be stretched to prevent buckling. It has a rather smooth surface that must be roughened to make it useful for pastels. Use a medium-grade sandpaper over a sanding block and carefully sand the paper in straight strokes, first in one direction, then the other. Sanding in a circular direction will tear the surface of the paper. Sand until a definite fuzzy, even tooth is raised over the entire surface. The surface absorbs watercolor almost like a blotter and creates unusual soft blurred edges. It is an ideal underpainting ground for pastels.

Mat Board

This product has generally been disregarded because of its impermanence, but several new lines of high-quality mat board offer exciting potential to the pastel artist. New Crescent Museum Rag Mat, which is 100 percent rag, is available in twenty-eight colors. Bainbridge Alphamat boards are not rag, but acid-free, neutral pH, and they are available in a large selection of fade-resistant colors. The textures vary quite a bit, but many are similar to pastel and charcoal papers. You will have to experiment to see which suits you best. Standard sizes are 32" x 40" (80 x 100 cm) and some are available as large as 40" x 60" (100 x 150 cm).

PASTEL GROUNDS

Each surface texture has a strong influence on the effect of the pastel application. These surfaces, which are reproduced actual size, show the dramatic differences from one ground to another.

Napped Surface

Velour paper

Webbed Surfaces

Silk-covered mat board

Fibrous Surfaces

Canson Mi-Teintes—embossed (rough) side

Canson Mi-Teintes—fibrous (smooth) side

Charcoal paper

Granular Surfaces

Fine sanded pastel paper (toned)

Fine granular board

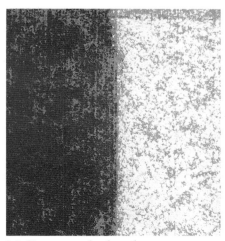

Medium granular board

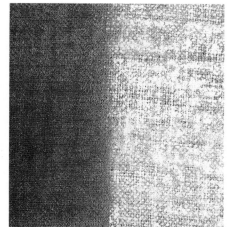

Unprimed linen

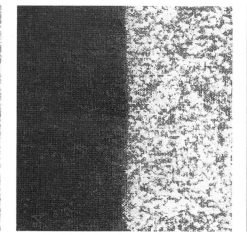

Muslin fabric board (toned)

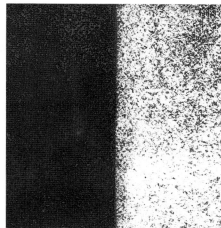

Pastelcloth (toned)

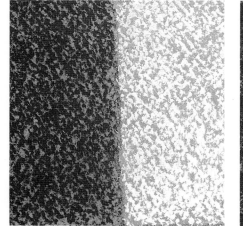

Arches cold-pressed watercolor paper (toned)

Museum rag board (toned)

Rag mat board

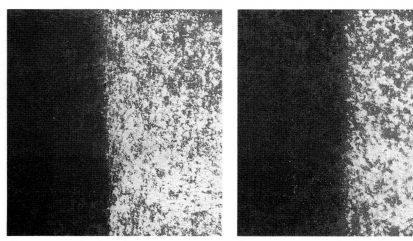

Coarse granular board

Very coarse granular board

Bainbridge and Miller offer a beautiful selection of fabric-covered mat boards in natural linen and silk. The 32″ x 40″ boards are available in a number of attractive muted tones. They have ideal textures for pastel. I do not know how fade resistant the colors are, but fading should not be a significant problem. The only drawbacks to these boards are that the fabric is mounted on ordinary cardboard and that they are quite expensive.

Sanded Pastel Paper

The ground of this paper contains a fine granular abrasive that is ideal for work with pastels and lately has become one of my favorite surfaces. Made in Germany by Ersta, the paper comes in four grades: X-fine 7/0, fine 5/0, medium P400, and rough P280. Sheets of 22″ x 28″ (56 x 72 cm) and rolls of 48″ x 10.9 yds. (1.2 x 9.7 m) are available. The fine grades are light tan, and the medium and rough are light gray in color. The paper is fairly heavy—like regular sandpaper—but buckles badly when exposed to high humidity, and I strongly recommend mounting it.

Some artists also use regular sandpaper for pastels. Several suitable varieties are available but they are usually sold only in small sheets. Large rolls can be ordered from the manufacturers, but at a premium price. Since these papers are not made for art purposes, there is some doubt about their permanence.

Canvas

Unprimed tightly woven canvas is an excellent ground for pastel—especially linen because of its permanence and lovely brown color. Canvas is a relatively coarse material on which it is somewhat difficult to produce fine detail, but it can hold many layers of pastel and produce fascinating effects.

Grumbacher makes two pastel canvases: one with a very fine marble dust ground and the other with a velour coating. They can be stretched on bars like regular canvas, but a piece of rigid cardboard should be placed between the canvas and the stretchers for support and for protection from vibration. Or the canvas can be tautly stretched over thin plywood and stapled from behind or glued to plywood or Masonite, which will be described later.

Pastelcloth

This is a unique new material developed especially for pastel that has wonderful potential. Pastelcloth is an acid-free, nonwoven, fine-toothed poly fabric with a white latex-based coating. It has an amazing sponge-like absorbency that grabs and holds on to pastel better than any surface I have used. Like canvas, it can be stretched or mounted for better durability. It is available by the yard from 40″ (100 cm) wide rolls. As of the time of this writing, it is available only at New York Central Art Supply (see List of Suppliers).

Many other materials can be used for pastel painting. Part of the fun is experimenting with surfaces not originally designed for pastel. Just remember that besides having an interesting texture, the surface must also be relatively permanent and durable.

PREPARING YOUR OWN GROUNDS

Two major breakthroughs in the development of my pastel techniques were linked to the discovery of new grounds. Early in my career I worked primarily on the traditional papers designed for pastel, enjoying the medium as a diversion from oil and watercolor painting. Then in 1975, while I was painting a large watercolor on Arches cold-pressed paper, something unexpected happened. The painting was not going well, and in attempting to salvage it with a few pastels, I became fascinated with a new effect. The transparent watercolor complimented the opaque pastel strokes on the grainy paper beautifully and created a rich paint quality. This technique presented a wide range of possibilities to explore, and pastel became more appealing to me than ever.

Then I discovered another ground that completely enthralled me. I had read about marble dust and sanded boards being used for pastel, but I was not able to find them ready-made. Following some vague directions, I experimented with making my own. After much trial and error, I produced a very uniform granular surface with powdered pumice stone. Its gritty tooth allowed the buildup of pastel layers with real impasto effects, and I developed new methods of using the medium. For the first time I felt that pastel truly rivaled oils in its capabilities.

Granular Boards

Excellent boards can be made by using finely pulverized pumice, quartz, marble, and other such stones. There are a number of methods of attaching the particles to the board. Some sources suggest covering the board with gum tragacanth or flour or starch paste and sprinkling it with the stone particles while still wet. The problem with this method is that it is almost impossible to get a

uniform coating. It is also better to avoid organic paste and gums in the ground because they attract mold. The most successful method I have found is to suspend the fine particles in thinned acrylic paint and brush the mixture on. This technique imparts an even surface with very fine brush lines. I have tried spraying the coating on but without as much success.

I have found that pumice produces the best results. It is sold in hardware stores for hand rubbing furniture and comes in four grades: coarse (F), medium (FF), fine (FFF), and very fine (FFFF). I prepare the majority of my boards with coarse and medium grades. The difference between the grades is actually slight; all are fairly fine powders. On the other hand, pumice sold by dental suppliers in coarse, medium, fine, and flour grades is significantly different. The flour grade is a fine powder, but the coarse grade is more like a fine sand. Quartz and marble are also available in a broad range of particle sizes. The very coarse grades produce extremely rough surfaces that can be worked on almost indefinitely without filling in the tooth, but refinements are difficult to make on them. The larger particles also file down the crayons incredibly fast, and I do not recommend their use until you are well experienced with finer grades. If you cannot find a local source, pumice and other pulverized stones can be ordered from City Chemical Corporation in New York (see List of Suppliers).

A number of supports can be used for the granular surface. Illustration board, the most practical and easiest to handle, is very rigid and available with 100 percent rag and high rag surfaces. The cold-pressed and heavy-weight boards are best. An extra-heavy board is recommended for painting on full 30″ x 40″ sheets. Museum rag board, discussed earlier, is another excellent choice. It is easier to apply an even coating on it than on illustration board, and brush lines tend to show less. Its multi-ply 100 percent rag content makes it very permanent, but large sheets may require mounting for support.

The granular ground can also be applied to wooden panels such as untempered Masonite or Lauan plywood. Sand the smooth surface of the Masonite somewhat so that the coating will adhere better. Best results are achieved on the plywood if it is primed with a coat of gesso and sanded to even the grain. The advantage of the panels is that they are very rigid and can be painted in large sizes. However, they are substantially heavier than the paper boards and are more difficult to cut and handle. Foam boards can also be used as a support, but I question the permanence of their thin paper surfaces. A new laminated foam panel called Gatorfoam, produced by the International Paper Company, shows excellent promise. The foam core is faced on both sides with smooth, stiff, waterproof veneers made of all-wood fibers and is very lightweight. The panels are available only in 48″ x 96″ (1.2 x 2.4 m) sheets and range from 3/16″ to 1 1/2″ (5 to 38 mm) thick. The sole disadvantage of Gatorfoam at this time seems to be its price, which is considerably greater than that of most other supports.

Directions

Basically the boards can be prepared with either a white ground, which is toned later, or with a colored ground of the desired shade. Usually I choose the latter because it saves a step. Acrylic paint is the perfect binder and coloring agent for the ground. Thinned gesso is used for the white, and tube or jar colors for the tones. Besides the coarseness of the pulverized stone used, the amount of particles in the paint will also affect the roughness of the boards. Naturally, the more stone used, the rougher the board will be. The acrylic is substantially thinned with water so that the brush lines will be as fine as possible.

I normally prepare at least three 30″ or 32″ x 40″ (76 x 100 cm) boards at a time and later cut them down to sizes I need. Before starting, the back side of the boards must be painted with a coat of gesso thinned with about one-third water to equalize the tension on both sides and prevent the boards from warping. The basic formulas for the granular surfaces are:

Formula for Three 30″ x 40″ Toned Granular Boards

2 fluid ounces tube or 3 fluid ounces (1/2 or 3/4 dL) acrylic paint (the tube paint is thicker, so less is required)
9 fluid ounces (3 dL) warm water
6 ounces by volume (1 3/4 dL) pulverized stone

Formula for Three 30″ x 40″ White Granular Boards

6 fluid ounces acrylic gesso
6 fluid ounces warm water
6 ounces by volume pulverized stone

Mix the acrylic and warm water thoroughly in a wide-mouth container, then stir in the pulverized stone. If you use tube paint, it is a good idea to add the water to it very gradually and premix with

PREPARING A GRANULAR BOARD

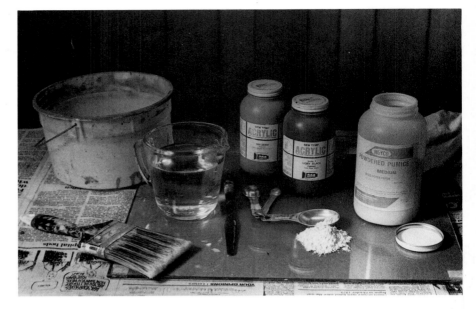

Materials for making granular grounds. The gritty tooth of these surfaces is produced with pumice or other powdered stone that is incorporated with acrylic paint. The mixture is thinned with water and brushed on a support such as illustration board.

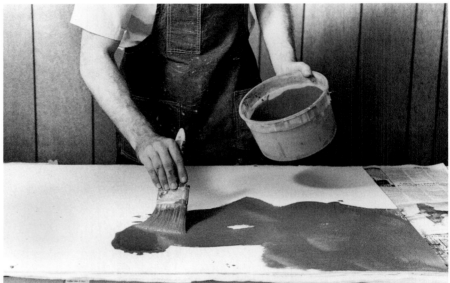

Step 1. The support here is extra heavyweight, 100 percent rag surface, cold-pressed illustration board. To keep the board from warping, paint its back side with a coat of gesso thinned with about one-third water and let dry. With a good-quality paintbrush, begin to apply the pumice and paint mixture. Every time you dip the brush into the container, stir the mixture well to ensure an even suspension of the pumice. Quickly cover the entire board with the mixture in broad, heavy strokes.

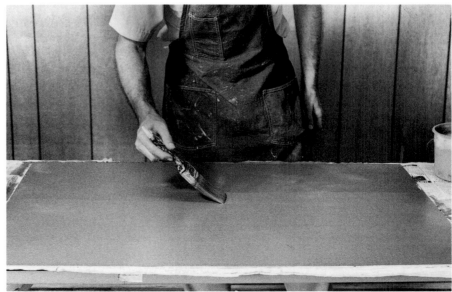

Step 2. Now smooth out the application with even parallel strokes. Repeat the strokes in the opposite direction, then finish by gently pulling the brush across once more with hardly any pressure.

a palette knife; otherwise it will be difficult to disperse. The pulverized stone is simply suspended in the thinned paint and, unless continuously stirred, will settle to the bottom.

With a good-quality 3″ to 4″ house-painting brush, begin to apply the paint to the board. With each dip of the brush in the paint, stir the bottom of the container to maintain an even suspension of the pulverized stone. Quickly cover the entire board with the mixture in broad heavy strokes and do not worry about getting it even right away. Then start at the top of one side of the board and pull the brush straight down in even strokes. Work all the way across the board, then repeat the same process in the opposite direction. To finish, gently pull the brush across one more time with hardly any pressure. If prepared properly, the coating will be very uniform, with only minimal brushstrokes showing. Should the mixture start to set before you can even the coating, mist it with water and rework the surface.

Although the formulas given here have been carefully tested, they are subject to variation because of differences in taste and materials. Precise measurements are not critical. Nevertheless, it is safer to overestimate the amount of acrylic because it is the binding agent. If the pulverized stone does not adhere securely once the coating is completely dry, increase the amount of acrylic paint in the formula. If the coating is not even or coarse enough, a second layer can be applied. When the coating is dry, stack the boards and place a sheet of plywood and heavy weights on them overnight. This completely flattens the boards. Try to store them horizontally or sandwiched between plywood when standing.

For toned boards, I prefer using earth colors and muted tones that are complementary to the more intense pastel colors. A good halftone is the most useful for general purposes, but slightly dark or slightly light shades also work well. Here are some color suggestions:

Pure burnt sienna, raw umber, or burnt umber
Burnt sienna mixed with various amounts of green for brownish olive and olive greens
Burnt sienna mixed with white for a mellow brownish pink (perfect for flesh)
Raw sienna mixed with a little black and white for a subdued gold

White or black can be added to any of these combinations for various tones. For white granular boards I sometimes add a touch of ochre to the gesso to make it easier to see when applying.

White granular boards can be toned with the same color combinations. Thin the acrylic with a lot of water and apply it with a sponge or wide paintbrush. To keep the board from warping, dampen the back of it with water so both sides will dry evenly. The boards can also be underpainted in multiple colors for a mixed-media technique.

Fabric Boards

Cotton or linen fabric and unprimed tightly woven canvas make excellent pastel grounds. They must be tightly stretched over rigid boards or mounted to them with glue. Gluing is the most durable method (especially for the lighter fabrics), and the glue also hardens the fabric, resulting in a sharper, more pronounced pastel stroke. The material I use most often is unbleached cotton muslin, which can be found in fabric stores in a variety of weights. I prefer the very lightest, which is tightly woven and used for sheeting. The texture is very fine but produces bold pastel strokes.

The support for the fabric must be very rigid. Even thick cardboard and foam-core boards have a tendency to bow when the glue dries. The problem can be remedied somewhat by painting the backs of the boards with the glue used and, when dry, placing them under heavy weights for a few days. The most reliable boards I have found are ¼″ Lauan plywood and ⅛″ Masonite. Large panels of Masonite require cribbing, but I have used the plywood as large as 36″ x 48″ (92 x 122 cm) without any extra support. If the plywood has any flaws, fill them in with spackling paste and sand the entire board until smooth.

The adhesive I have used most successfully is rabbitskin glue in granular form. It is easy to handle, very strong, sizes the fabric, and adds extra tooth. Make a solution of it by soaking the glue in cold water until softened and swelled. Place the container in a pan of cold water and gradually warm it, but keep the water from boiling. When completely warmed, stir until it is a smooth liquid. For use as an adhesive, the amount of glue must be greater than recommended for sizing only. Approximately 3 ounces of glue to a pint of water makes enough solution to prepare three 24″ x 30″ (60 x 76 cm) fabric boards.

Although the mounting is easier if you have someone to assist you, it is not too difficult to do by yourself. Start by cutting the fabric about an inch wider all around than the board. If you do not have help, lay the cloth evenly over the board and pin one side to the worktable. Then fold the other side of the cloth back and let it hang over the

side of the table. While the glue is still warm and liquid (it gels when cold), brush a heavy coat of it on the board. Now bring the cloth back over the board, pulling it tautly at the two unpinned corners. If you have a partner, stretch the fabric out by pulling on all four corners, then carefully align and place it on the glue-covered board. With another cloth in hand, rub from the center outward to work out any wrinkles and firmly secure the fabric. Next brush the solution across the entire surface of the fabric. This thoroughly sizes and glues the fabric to the board. Let the glue dry and trim the excess cloth with a razor blade. If the board warps any after drying, place it under a heavy weight overnight to flatten it. If you want to tone the boards, use oil paint thinned with tur-

pentine or acrylics and apply with a rag or wide brush. For an unusual and especially grainy surface, you can even apply the acrylic pulverized stone formula.

Acrylic gesso also works well as an adhesive, but it tends to fill in the texture of the fabric more than rabbitskin glue. It also, of course, makes the fabric white and demands toning.

If you simply want to glue the fabric to the board without sizing the surface, white glue such as Elmer's Glue-All probably gives the best results. Spread a heavy even layer on the board only and firmly secure the cloth with hard rubbing. Do not use oil paint to tone unsized fabrics because it will eventually cause the cloth to deteriorate.

PREPARING A FABRIC BOARD

Materials for making fabric boards. *Other materials can be substituted, but these are the ones I use most often. The fabric is unbleached cotton muslin, the board is Lauan plywood, and the adhesive is rabbitskin glue.*

Step 1. *I start by aligning the fabric over the board and tacking one side of the fabric to the table. Then I fold the fabric back and let it hang over the edge of the table. Being careful not to move the board out of position, I apply a heavy coat of rabbitskin glue to the board.*

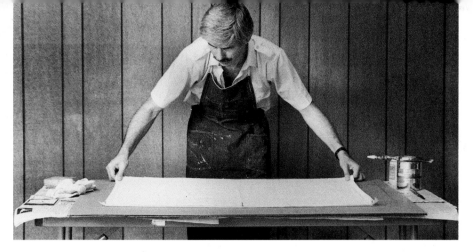

Step 2. *I have lifted the fabric and am now tautly stretching it over the glue-coated board.*

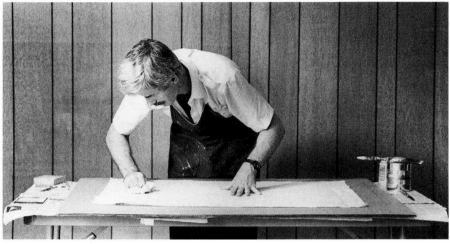

Step 3. *I rub the fabric from the center outward to smooth out any wrinkles and firmly secure it to the board.*

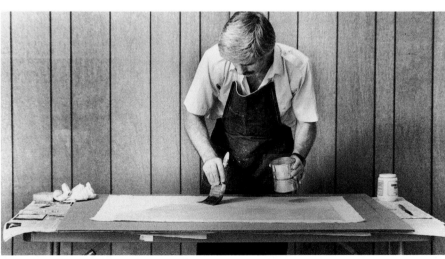

Step 4. *Next I brush a final coat of glue across the fabric to size it and thoroughly glue it to the board.*

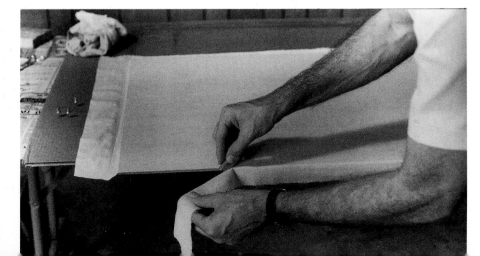

Step 5. *When the glue is dry, I trim the excess fabric from the board with a razor blade. The board is now ready to use.*

MOUNTING PAPER

Conservators generally frown on mounting original works of art because adhesives and supports often have a deleterious effect. As a rule, if an artwork does not need mounting to make it more durable or permanent, then it is better not to mount it. The fragile nature of pastel layers, however, demands that the paper not curl or buckle—making mounting often necessary and more important for pastels than for works in other media.

Mounting paper can be safe if some important guidelines are followed. Both the adhesive and support must be stable and not cause embrittlement or discoloration of the paper with age; ideally, the adhesive should be reversible so that, if the paper ever needed restoration, it could be separated from the support. Unfortunately, many materials commonly used for mounting do not meet these requirements and are unsafe. Especially avoid using spray adhesives, rubber cement, and most dry-mounting adhesives, and never mount an original artwork on corrugated or ordinary cardboard. The most widely accepted safe support is 4-ply 100 percent rag, acid-free museum board with calcium carbonate buffering. However, museum board is not rigid enough to support large sheets of paper, and I recommend acid-free foam board when a more rigid support is needed. Some conservators have questioned the permanence of foam board—mainly because it is not time-tested—but I feel it is superior.

The easiest time to mount paper is before the artwork is started. Once the paper is mounted to a stiff board, however, pastel strokes do not take as evenly to the surface as they do when the paper is on a softer support. For this reason, I usually begin a pastel on a drawing board with the paper cushioned by a thin rubber padding or additional sheets of paper. When nearly finished, I mount the paper and complete the painting.

Pastels are capable of withstanding considerable vertical pressure without injury, but smear easily with any lateral movements, so you must handle them very carefully. During mounting, heavy pressure is applied to a sheet of protective paper placed over the pastel and a small amount of pigment will stick to the paper. Therefore I do not recommend mounting a finished pastel by another artist unless he or she is available to do touch-up work if required.

The mounting methods I have used successfully are as follows:

Stretching

This is a simple, very safe method because adhesive is applied only to the edges of the paper. Lay the artwork face down on a smooth surface and slightly dampen its back with a well-wrung sponge. Apply about a ½" margin of wheat paste, starch paste, or Elmer's School Glue (all are reversible with water) around the edges. Turn the artwork face up on a mounting board that is cut slightly larger. Cover it with a sheet of smooth paper and carefully press it flat. Check to be sure that the edges of the artwork are well secured, then place a piece of plywood and weights on top of it until dry. The paper should stretch out tight and smooth, but be careful of wetting the paper too much because, when it dries, it may warp the mounting board. On the other hand, if the mounted paper is ever subjected to very high humidity, the paper may begin to sag a little.

Pasting

The entire back of the paper is covered with paste in this method. The only product I have found that does this successfully is called Yes. It is a vegetable paste that has the amazing property of not curling or wrinkling paper regardless of how thin the stock is. Yes paste contains corn dextrine, corn syrup, and water, with a small percentage of preservative. It has a pH of 6.0 and is reversible for restoration and conservation purposes. I discovered it only a few years ago, and you may have to search for it, but it has been around since 1928.

Start by laying the pastel face down and place small pieces of masking tape at the top and bottom to prevent the paper from accidentally sliding. With a stiff brush, apply the Yes paste *undiluted* and spread it evenly over the back of the paper. Carefully turn the pastel face up on a mounting board and cover it with a sheet of smooth paper. Beginning from the center, roll the paper out flat with a soft rubber brayer. Beware of trapping air bubbles under the paper. If necessary, it can be lifted and rolled out again. With thick papers, it is usually necessary to place plywood and weights on top for several hours to keep the edges from curling up.

I have had a hard time finding much fault with Yes paste. The only minor shortcomings are that it has a pH of 6.0, which is slightly acidic (6.5 to 7.0 is considered neutral pH and acid-free), and it cannot be used with photographic papers because it tends to yellow the photochemicals.

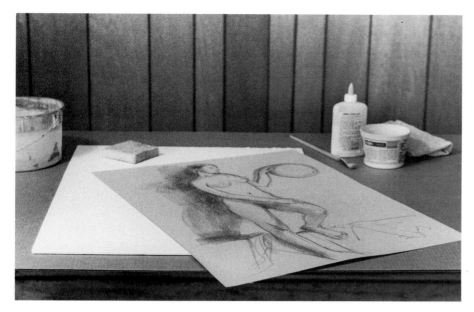

MOUNTING BY STRETCHING

Materials for mounting paper by stretching. *This drawing is being mounted to make the paper more durable before it is developed with full color. A foam board is being used for the support and white glue for the adhesive. Also needed are water, a sponge, and a glue brush.*

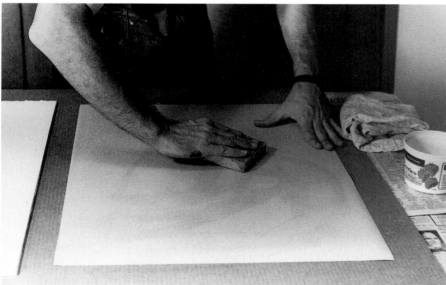

Step 1. *Lay the paper face down on a smooth surface and slightly dampen the back with a well-wrung-out sponge.*

Step 2. *Apply about ¹/₂" margin of glue or paste all around the edges.*

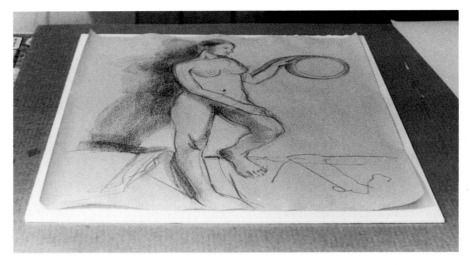

Step 3. *Turn the paper face up and center on a mounting board that has been cut slightly larger.*

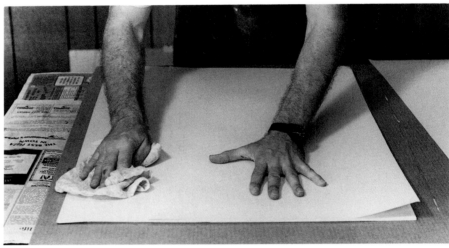

Step 4. *Cover the drawing with smooth paper and carefully rub it flat with your hands. Then place a sheet of plywood and weights on top of it until dry.*

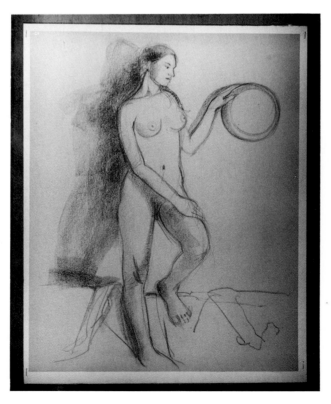

Result. *The paper is stretched tight and smooth. It now has a rigid base and is much less fragile.*

MOUNTING BY PASTING

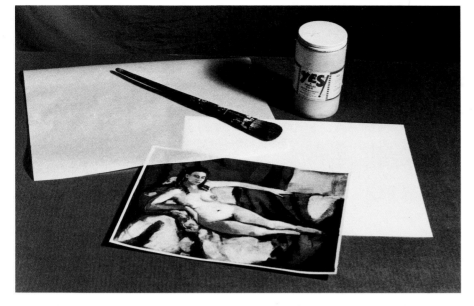

Materials for mounting paper by pasting. *This small unfinished pastel is on sanded pastel paper, which buckles badly if not mounted. The support is 4-ply museum rag board and the adhesive is Yes paste. Also pictured are a sheet of protective paper and a stiff bristle brush for the paste.*

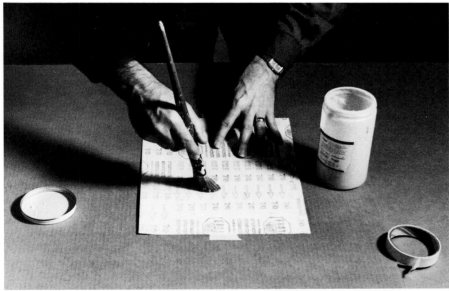

Step 1. *Lay the pastel face down and tape at the top and bottom to prevent the paper from sliding. Apply undiluted Yes paste evenly over the back of the paper.*

Step 2. *Carefully turn the pastel face up on the mounting board.*

39

Step 3. *Cover the pastel with a protective paper and roll it out flat with a soft rubber brayer.*

Step 4. *Place plywood and weights on top for several hours.*

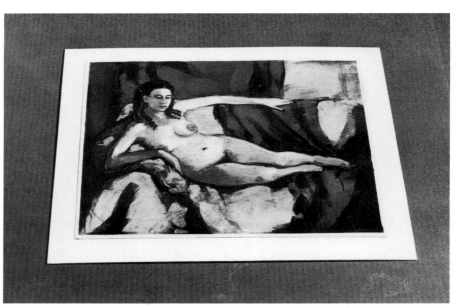

Result. *Firmly secured, the pastel is now ready to be completed.*

Polyamide Web Adhesive

The dry-mounting adhesives generally used by most framers are unsafe for original works of art. In time they may bleed through, causing serious damage to the artwork, and most are irreversible. However, a conservator recently introduced me to a dry-mounting, web-adhesive tissue (a low-melting thermoplastic polyamide in fine web form) that is very stable, reversible, and easy to use. It weighs only 20 grams per square yard and is widely used in the textile industry to bond fabrics. It bonds at 260° to 325°F in eight to ten seconds, and only a household iron is needed as a heat source—not an expensive dry-mounting press. Two sources for web adhesive are Conservation Materials Ltd. and Sumner Laboratories (see List of Suppliers).

To use web adhesive, cut a sheet of it slightly larger than the artwork to be mounted. Center the webbing on the mounting board and place the artwork over it. Cover the artwork with a sheet of silicone release paper (available from the above sources), which will not stick to the excess webbing when it is melted. Then, to activate the bond, use a household iron set at a medium temperature. Applying light pressure, move the iron very slowly across the release paper, pausing a few seconds with each overlapping stroke. Work on a small area at a time until it is bonded, then move to an adjoining area. Lift the release paper from one side occasionally to make sure the bonding is working. If not, it may be necessary to raise the temperature of the iron or hold the iron in an area for a longer time. I strongly recommend testing the process with some scrap paper.

Based on the information I have now, polyamide web adhesive may be the best mounting material available.

DRY MOUNTING WITH WEB ADHESIVE

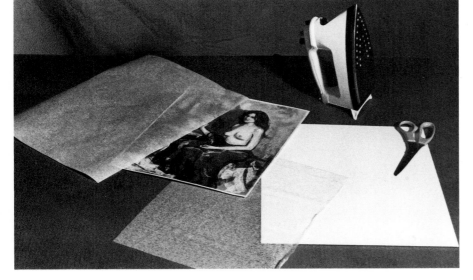

Materials for mounting with web adhesive. *Between the small unfinished pastel and the 4-ply museum rag board is the web-adhesive tissue. Placed on top of the pastel is silicone-release paper, which is needed to protect the pastel. A household iron is used to activate the bond.*

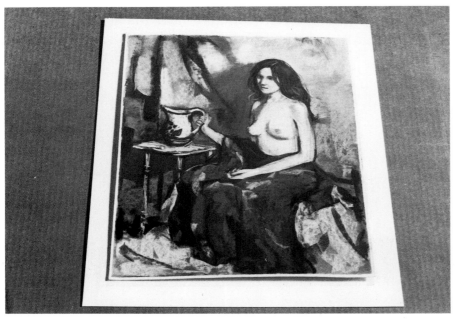

Step 1. *Cut a piece of webbing slightly larger than the artwork and place it between the artwork and the mounting board.*

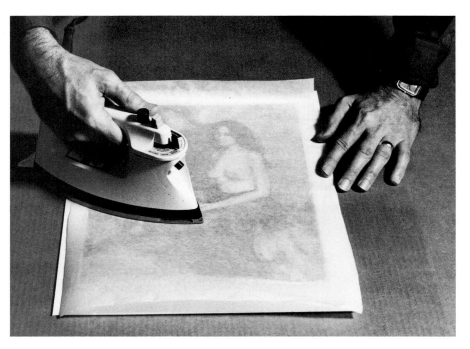

Step 2. *Place the silicone-release paper over the pastel. Set the iron at a medium temperature and very slowly move it across the surface, holding it still for a few seconds in each overlapping area.*

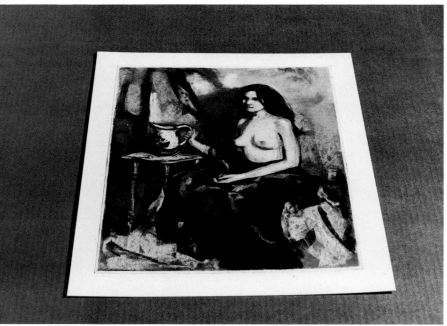

Result. *Check to be sure that the bond is complete. The hot iron can be reapplied at any time if an area is not secure.*

CHAPTER THREE

Lighting and Equipment

This chapter will present the most important considerations in lighting for a studio and the equipment that is needed or useful for pastel painting. The right tools and a well-planned work space are essential for an environment that is conducive to productivity and creativity.

LIGHTING

Studio Lighting

Good lighting without doubt is the most important requirement for a studio. Prior to the twentieth century, natural daylight was the only dependable light available. Visions of artists painting by candlelight or gaslight may be romantic but are hardly realistic. Today the options are far greater. With artificial lighting, complete control is possible and the light is constant twenty-four hours a day. Many artists, however, still consider natural light to be the best for painting, so the ideal situation is probably to have both natural and artificial light available.

The best source of natural light is a northern exposure such as a skylight or high windows. A skylight allows in three times as much light as a window the same size, but it must be positioned at a steep angle of 45 degrees or more to avoid direct sunlight. A northern exposure affords more constant light than any other direction. It is also cool and diffuses itself evenly through space. One can study the work of the masters to discern the lighting they employed. For instance, the cool light of a northern exposure is quite evident in the work of Jan Vermeer (1632–1675). He posed all of his subjects in front of northern windows and obviously painted by the same light. Eugene Delacroix (1798–1863), on the other hand, built his last studio with a southern exposure and preferred its

warm light. With this exposure, a shade of translucent white cloth is needed to diffuse the direct sunlight.

Whatever source of light you use, you must arrange the easel so that shadows are not cast across the painting by your hand. As a general guideline, a right-handed person should have the light coming in from the left and a left-handed person, the reverse. Sometimes it may be necessary to drape cloth on windows from about five feet and below to eliminate problems with shadows and glare.

Although natural light has traditionally been considered ideal, artificial light is usually more practical and convenient, especially considering the makeshift nature of most studios. Also, paintings are almost always viewed under artificial light, so it makes sense to paint by it. The best artificial light comes from fluorescent lamps or tubes. A fixture with four 4' tubes or two 8' tubes positioned directly over the work area should give even illumination to the painting and worktable, as well as a large surrounding area. It is important that the light be relatively uniform throughout the studio, as uneven lighting can be very tiring on the eyes. In a large room, more than one light fixture may be necessary.

Deluxe Cool White fluorescent lamps, which simulate the relatively warm daylight of mid-afternoon, are probably the most popular because of their wide availability. The manufacturers also produce other so-called color-corrected lights that simulate cooler types of daylight, such as that from a north skylight. You may want to try them, but I do not find the subtle differences to be an advantage. Incandescent bulbs by themselves are not advised for studio lighting because their light is too yellow and tends to dull cool colors. They

Studio with artificial lighting. *Like many artists, I have always had plans to build the perfect studio with a huge northern exposure, but because I have moved around a lot, I have usually ended up converting a less-than-ideal room into a studio. Thus, I have had to depend on artificial light but have found it very satisfactory and would plan to use it in any future studio as well.*

My studio has two 8' foot cool-white fluorescent lamps positioned directly over the work area as the main light source. The light is supplemented with incandescent lights because I believe the blend creates better color balance. The window does not add significantly to the lighting because of its location and small size. I generally pull the easel closer to the pastel table and work more directly under the lights than is shown here. I set up still lifes on the small table with the landscape resting on it, but I use another studio when working directly from a model.

also produce harsh shadows and do not provide even illumination. However, a blend of fluorescent and incandescent light creates an ideally balanced artificial light. Colors in a painting rendered under this combination will not change noticeably under daylight or a gallery spotlight. A single 100-watt incandescent bulb or several smaller bulbs supplementing the fluorescent lamps should be sufficient. Avoid any kind of direct spotlight on your painting or it will give it a false sense of brilliance. When the spot is turned off, the painting may look very dull.

Lighting the Subject
When painting directly from a model or still life arrangement, further consideration must be given to their lighting. A dominant light source angled from one side and above eye level is generally best. It greatly simplifies the forms and creates striking three-dimensional effects. A secondary light source from another direction can add interest, but it should not compete with the dominant source, or confusion and a flattening of the forms will result. The old masters in particular relied on this type of lighting to produce depth and drama in their paintings.

Lighting the subject. These photographs demonstrate the three-dimensional qualities and compositional effects that lighting has on forms. Left: Under general studio illumination, the statues have little contrast and appear relatively flat. Right: The addition of a spotlight adds drama and interest. The forms appear much more rounded and three-dimensional.

THE ARTIST IN HIS STUDIO, *by Jan Vermeer, Kunsthistorisches Museum, Vienna.*

This painting provides a wealth of information about the ideal use of natural lighting in a studio and the way this master worked. The light source is obviously from a window facing north, which produces a cool, constant illumination. Both the subject and the artist's canvas are receiving the same light, but notice that the brighter illumination is on the subject rather than on the canvas. Also, because the light is coming in from the left, the artist's right hand does not cast a shadow across the painting.

If daylight is used to illuminate the subject, a northern exposure is again suggested because of its constancy. Try to position your easel and subject so that both are receiving the same light. If this is not possible, it is usually better to have the brighter illumination on the subject. Other exposures can be used, but the light will change throughout the day.

Of course, the simplest way to avoid the problem of changing daylight is to use artificial light on the subject. You can experiment with different types of incandescent lamps for the main light source. Spotlights are the most dramatic, floodlights create more diffused lighting, and often ordinary household bulbs create the most pleasing effects. All these lamps emit a warm yellowish light. In a studio with cool fluorescent lighting or daylight from a northern exposure, a pleasing and natural complement of warm lights and cool shadows is created on the subject. If you prefer the overall cool light of a northern exposure, the effect can be simulated by mounting a fluorescent light fixture vertically on a support stand and positioning it to one side. The effect will be very much like the light from an open window. Photography light stands are the handiest means of positioning incandescent lights. They offer the possibility of experimentation with unusual angles and effects, although simple and natural effects are usually most desirable.

EQUIPMENT AND SUPPLIES

Easel
The most important requirement for an easel is that it be sturdy. It must also allow the painting to be positioned vertically or leaning slightly forward so that pastel dust falls away from the picture and does not collect on it. In addition to a solid studio easel, a lightweight portable easel is indispensable for painting outdoors. For many years I have used an inexpensive Stanrite aluminum extension easel that has worked very well. It is quite sturdy for small paintings, and the cross braces are convenient for holding my pastel supplies. A fancy French folding easel with a built-in paintbox might be preferred by some artists, but I cannot bring myself to buy one as long as my old easel does a good job.

Table
The worktable should be sturdy and large enough to hold your pastels and other supplies without overcrowding. Mine is a standard cafeteria-type table, 30″ x 72″ and about 30″ high (76 x 183 x 76 cm), which is a convenient height for standing or sitting on a high stool while working. I keep the table on my right side and as close as possible for easy reach. If you are using daylight as your primary light source, always place the table on the side the light is coming from so that your pastels are well illuminated and your body does not cast shadows across them.

Drawing Board
The simple purpose of a drawing board is to support the artwork while it is being worked on. Every pastel artist needs at least a half-dozen or more to hold works in progress. The best kind are

Painting outdoors. I use a portable aluminum extension easel on field trips. It is quite sturdy for small pictures, and the cross braces serve well as a support for my pastel box. The easel also has spikes at the bottom of each leg that can be pushed into the ground to secure it on windy days. However, on more than one occasion I have had to weight or tie the easel down to prevent it and the painting from taking off like a kite.

Notice that my pastel surface is stapled to a larger drawing board. The board provides a rigid support, and the margins help me focus better on the picture's composition.

inexpensive. Buy a 4' x 8' (1.2 x 2.4 m) sheet of any good-quality ¼" plywood, such as Lauan, and cut it into the various sizes you may need. Building boards such as Celotex and Homosote are also fairly good, but do not hold staples well.

Most pastel paper should be attached to the drawing board only at the top, and the bottom of the paper should hang free to allow for expansion from humidity and handling. Heavier materials—like illustration boards and watercolor papers—should be stapled on all sides to keep them flat. Whenever possible, I use a drawing board that is several inches larger than the artwork so that there is a border surrounding it. This margin serves as a kind of temporary mat that helps me focus on the picture's composition and also gives the artwork some breathing space.

When working on unmounted paper, it is a good idea to layer several sheets of paper under the artwork. This creates a slightly cushioned surface that accepts the pastel much more evenly than a hard surface. An even better and convenient solution is to cushion the drawing board with a thin rubber padding. I have two boards with ¼" close-cell sponge (a very dense, firm foam rubber that is available from a rubber dealer) glued to them for this purpose.

Fixative
This is a crucial ingredient in pastel painting. Fixative serves three important purposes: it makes the painting less fragile by helping bind the pigment to the surface; it imparts extra tooth, even on a surface that has become slick; it can be used to tone down or darken selected areas of a picture.

A very fine, well-controlled spray is essential in applying fixative. For this reason, I recommend aerosol spray cans over atomizers or hand sprayers. Commercially prepared fixatives are quite good, and I can see no advantages to preparing your own. Workable fixatives such as Grumbacher Tuffilm, Krylon Workable, and Blair Spray Fix (regular or no odor) are all excellent pastel fixatives. Acrylic sprays such as Krylon Crystal Clear are stronger and surprisingly better at creating tooth than the workable fixatives. However, they also darken the colors much more and should be reserved for early stages or for repairing the surface tooth. Generally avoid fixatives that are not described as workable for late stages of the pastel. Never use hair sprays. They are not intended for permanent artwork.

Caution, of course, should be exercised in spraying fixatives. Use them with adequate ventilation, and avoid prolonged breathing of the vapors. If possible, do most of the spraying outdoors or use a window fan to exhaust the vapors.

Ben Stahl Spray Glaze
This pigmented aerosol spray can add a controlled, colored glaze over a painting or drawing. It is available in six colors: blue, green, neutral tint, raw umber, red, and yellow. Spray glaze is a relatively new product that I have only recently begun to combine with pastel. I sometimes use it in place of fixative in areas where I want to add color as well as fix the surface. Like a glaze in oil painting, it can help create color harmony and add depth to colors, but beware that it also may darken the colors significantly, especially if the pastel is on a dark ground. It can be used to tone light grounds or add color to drawings, and the surface remains workable. Practice controlling the spray before you use it on a painting. Spraying from 1½ to 3 feet produces a fine, delicate tint. At 6 inches and held steady, it produces a heavy, glossy film—which should be avoided in a pastel. Use the same precautions with spray glaze that you would with fixatives.

Paints
Watercolor, acrylic, gouache, casein, tempera, oil, alkyd—just about any good paint can be used with pastels as a thin underpainting. Thick layers of oil paint should be particularly avoided, however, because they are glossy and may take months to stabilize—which can result in a poor adhesion of the pastel layers. When oil paints or alkyds are used, the ground must be sized with a thinned coat of shellac, hide glue, acrylic medium, or such to protect it from the deteriorating effect of the oil. Oil paint should be thinned with a solvent to minimize the amount of oil and to speed drying, and it can also be squeezed on newspapers first to absorb excess oil. Water-based paints can be applied to most surfaces, although thin papers should generally be avoided because they may buckle.

Miscellaneous Supplies
In addition to the major supplies already listed, there are some other items that are also important:

Vine charcoal is very useful for preliminary drawing and blocking in and can be easily wiped off and changed. I like the thin, soft variety best.

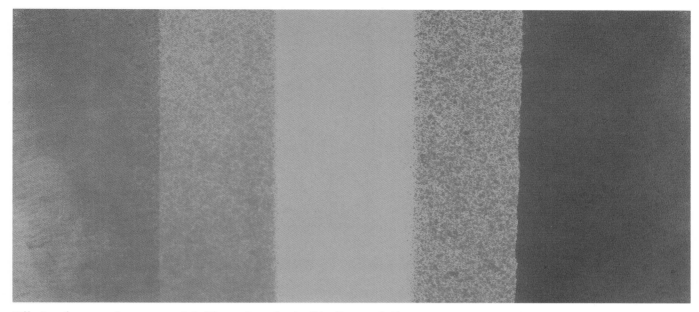

Effects of spray glaze on pastel. The center color in this diagram is the gray pastel that was blended across the paper. On both sides is the same color after it has been sprayed with light and heavy coats of spray glaze.

A kneaded eraser can lift color off without smearing when it is firmly pressed against the pastel surface. It is also used for regular erasing with pastel or Conté pencil drawings on paper.

Old artist paintbrushes, a 1¹/₂" to 2"-wide house-painting brush, and paper stumps are useful for blending. Stiff bristle brushes are also quite good for scrubbing color off a surface.

Rags and paper towels are also useful for blending, but their most important function is to clean the pastel crayons as you use them.

Single-edge razor blades and sandpaper pads are employed to sharpen or file hard pastels and pencils to a point. The razor blade is also useful for scraping pigment from a surface.

A staple gun with ¹/₄" to ⁵/₁₆" staples is the best way to attach illustration boards and watercolor papers to a drawing board.

Clamps, pushpins, and thumbtacks are the best way to attach thin papers to a drawing board.

A mahlstick is simply a stick used to steady and support your hand while doing fine detail. Special collapsible aluminum sticks are made with rubber tips, but any old stick will do as well.

A mirror is an invaluable aid that allows you to look at your painting with a fresh viewpoint. Seeing the images in reverse immediately brings out any flaws in the drawing and design. I use a small hand mirror about 9" x 12" (23 x 30 cm) at the easel and a large mirror set about 12' (3.5 m) back. When working from a model or still life, it is also very helpful to view the painting and subject in the mirror at the same time.

A viewfinder is very handy for composing the design of the picture. One can be easily made by cutting an opening about 4¹/₂" x 6" (11 x 15 cm) or smaller in the center of a larger piece of stiff cardboard. To adjust the size of the opening, simply slide a narrow strip of cardboard across it until the desired shape is achieved. A viewfinder can also be made by cutting two *L* shapes out of cardboard and joining them together with clips to form a rectangle of any proportion.

Using the viewfinder is like looking at a view through a window. The subject matter is arbitrarily cropped to fit within a neat rectangular shape. Look through the viewfinder with one eye shut. The closer it is, the more you will see. At arm's length, the view will be the smallest. Experiment with moving the viewfinder around and back and forth to determine the best composition. This will be a big help in letting you know what and how much to include.

MORNING AT MYNELLE GARDENS, *granular board, 28" × 32" (71 × 81 cm). Collection Mr. and Mrs. M. F. Kahlmus.*

CHAPTER FOUR

Basic Color and Painting Concepts

Pastel is unique for many reasons, but primarily because it is a form of painting with dry color. Consequently, some basic concepts about its application and performance are different from those of wet media. It is important to understand these in order to exploit pastel's enormous potential. This chapter will deal with the properties of pastel that set it apart, as well as those that relate it to other media.

Painting with Dry Color!
The ramifications of this are extensive. Without any premixing, the artist commands an extraordinary range of individual colors that are unrivaled for their purity and intensity. Moreover, because the colors are dry, they must be applied in separate strokes. Freshness and luminosity can be achieved easily with less chance of the dulling that is characteristic of mixing color on a palette. Pastel is also more convenient and less complicated to use than wet media. Little setting-up time is required. The artist can leave his work and resume at any time and is free of many of the technical problems and anxieties inherent in wet media.

Largely because it is dry, pastel can produce diverse drawing and painting effects. The tip of the crayon can make lines, and its side can lay on color like a brush. Although it cannot be truly glazed or built up in thickness to the extent of oil paint, it can achieve translucent and impasto effects. In addition, pastel can be used on many surfaces and combined with other media to produce unlimited effects.

Reflection of Light on Pastel
There is an intrinsic difference between the way light is reflected from the dried paint films of wet media and the layers of pastel. The pigment in most wet media is encased in a syrupy vehicle that settles to a smooth, level film when dry. Essentially, light strikes a single flat plane and is reflected directly back to the eye. By contrast, pastel layers are virtually unaffected by the leveling actions of a vehicle, and the texture of the dry pigment is maintained. Rather than being a smooth film, pastel layers are composed of thousands of tiny particles of pure pigment stacked on top of one another. Thus, the surface is actually three-dimensional and airy, allowing light to penetrate deeply. Light is reflected from multiple planes and angles, producing a sort of vibrancy and a richness of color that are not possible with a

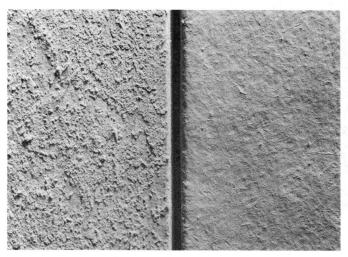

Magnified view of a pastel layer and a wet medium paint film. This $6\times$ magnification clearly shows the intrinsic difference between the effect of light on the two different media. The pastel on the left and the paint (acrylic) on the right are approximately the same color and were applied in a single opaque layer to the same cardboard surface. Upon drying, the paint settled to a smooth film. By contrast, the pastel has a broken texture, and light is reflected from individual particles of pure pigment. The result is a vibrancy that is not possible with a slick paint film.

addition to gradations of value, the lines could also be used to convey direction, movement, and even emotion. In the hands of a great draftsman like Rembrandt, hatching was spontaneous and brimming with infinite variety—lines swirled, soared, crisscrossed, and zigzagged. It created an intricate network of lines throughout the composition that served as a powerful unifying force.

Pastel shares a close relationship to graphic art because it also is applied in strokes. It is natural that pastelists employ hatching. Linear strokes of different colors can be juxtaposed and crisscrossed to produce visual energy and radiant color. When intense colors are loosely interlaced, the effect is pulsating. When the interlacing is performed with fine, tightly spaced strokes, the result is calmer, but there is still a subtle animation. To get an idea of the effect, imagine a cloth woven of threads of intense red and blue. When the spacing is so close, the eye cannot quite focus on both colors at

the same time and so the colors seem to vibrate and intermingle optically to create a vibrant purple. This is a classic example of optical color mixing. Variations of subtlety, emphasis, and gradation therefore can be articulated by the relative intensity, contrast, size, and spacing of the color strokes.

Hatching is most effective when it is done spontaneously and does not look contrived. One need only study the pastels of Degas to understand this. Parallel strokes in his work tend to flow with the forms and curve around figures and structures, although he did not hesitate to arbitrarily paint an entire figure in all vertical lines if it served his purpose. In areas where he wanted to create more emphasis or wished to fuse one form into another, he often crosshatched. Hatching serves as a unifying element in his compositions, creating an overall fabric of connecting lines and animated color.

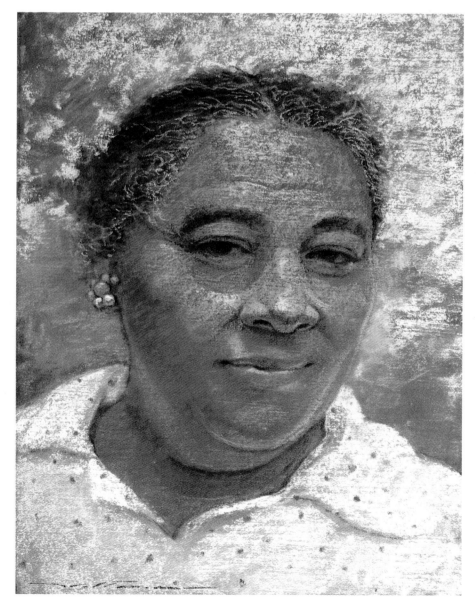

Study for **GERALDINE,** *granular board, 14" × 10" (36 × 25 cm). Collection Mr. and Mrs. Robert Wilson.*

Quite a lot of blending was employed in the early stages of this little portrait, as is still evident in the middle tones. However, the vibrancy of the lights was accomplished with a strong texturing effect.

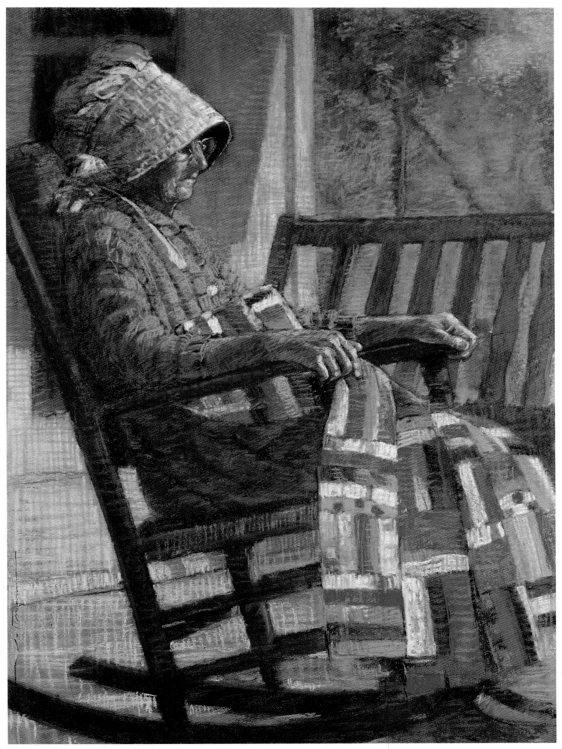

QUIET MOMENTS, *museum rag board, 34" × 24" (86 × 61 cm). Collection Dr. and Mrs. Edsel Ford Stewart.*

I roughened the paper surface with sandpaper to produce a more pronounced tooth. Then I underpainted with watercolor and overlaid broad tones of pastel. From that point on, I developed the forms with a hatching and crosshatching technique. The linear strokes serve as a strong unifying force in the composition. Basically the color scheme is made up of complementary colors, but harmony and color vibrancy are achieved by the constant interweaving of the colors. For example, the violet colors are laced throughout the pale yellow wall, the blue sweater, and the green foliage, creating an overall fabric of related colors even in unrelated areas.

JIM LAUGHING, *granular board, 19″ × 13″ (48 × 33 cm). Collection Beverly Richards.*

This portrait of a kind old friend of mine was done with linear strokes that were free and spontaneous and seemed to fit the jovial mood of the subject. I sprayed the first layers of pastel with water and worked into it with brushes, creating a wash underpainting effect— some of which can still be seen in the shirt.

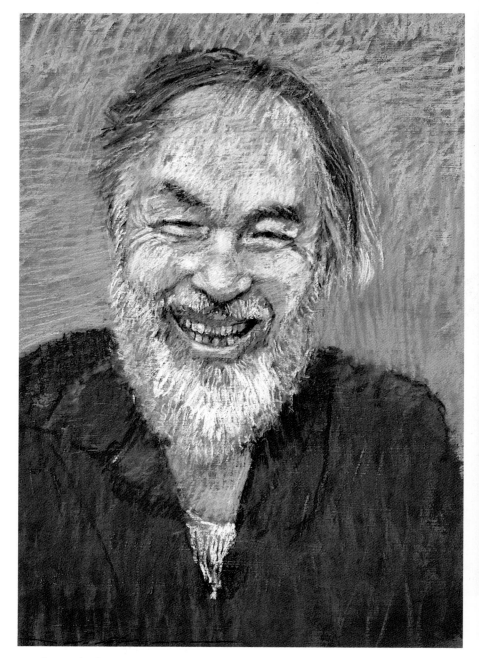

Dabbing (dots and dashes). I have adapted this term for the sake of simplicity and clarity. It is used to describe a technique variously called pointillism, impressionism, divisionism, and dotting. It refers to dabs or short strokes of color applied with the tip of the pastel or a brush. Dabbing is employed in much the same manner as hatching—by juxtaposition and superimposition. However, dots and dashes actually occur in nature quite often, whereas hatching lines usually are an invention. Try to think of a landscape without dot and dash shapes—trees without leaves? water without sparkle? soil without granules or pebbles? Artists recognized this long ago, and dabbing has been part of painting technique for centuries.

In the haunting paintings of Jan Vermeer (1632–1675), for example, there is an almost uncanny treatment of the play of light on textured surfaces. Upon close examination, the sparkling areas in each consist of little dots of flattened paint, resembling tiny overlapping sequins of light. John Constable (1776–1837) employed a similar method, creating brilliant accents throughout his paintings with tiny dabs of pure white, silver, ivory, and gold. In fact, he used so much white highlighting that critics dubbed it "Constable sleet and snow."

Dabbing was an especially suitable method for the Impressionists, particularly Claude Monet (1840–1926) and Camille Pissarro (1830–1903). Their preoccupation with duplicating the most

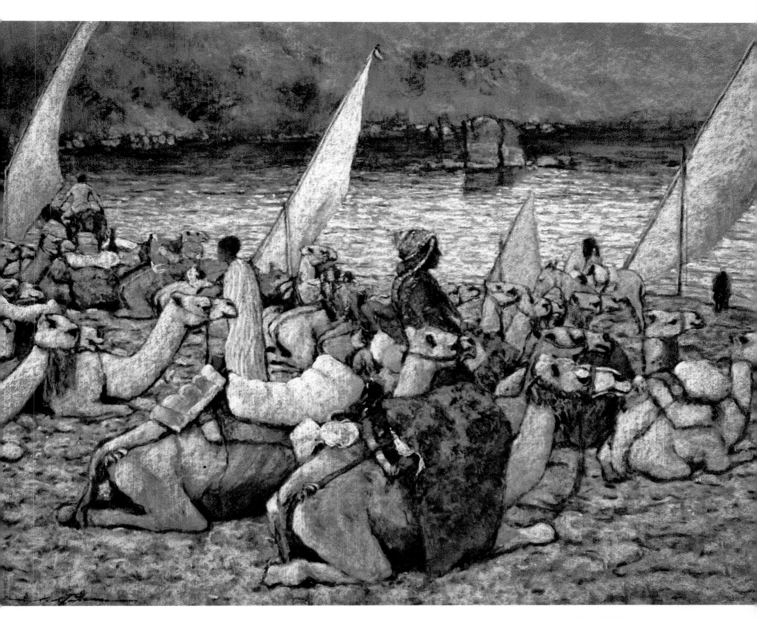

JOURNEY TO THE NILE, *granular board, 29" × 39" (74 × 99 cm). Collection Mr. and Mrs. William Conger.*

subtle color changes in nature demanded the application of paint in small opaque touches called *taches* rather than in large areas of color or washes. With this approach they could move at ease from one part of the painting to another, adding dabs of color until just the right effect was achieved.

The Neo-Impressionist painter Georges Seurat (1859–1891) refined the theory of optical color mixing to a science that became known as pointillism. He composed large figurative compositions consisting entirely of dots of varying colors and sizes. One color was played against another, creating vibrating color effects. William Innes Homer, in *Seurat and the Science of Painting,* writes: "Seurat used optical mixture not to create resultant colors that are more intense than their individual components but rather to duplicate the qualities of transparency and luminosity in half-tones and

Although I very seldom employ a pure dabbing technique, I often incorporate the effect to enliven an area or to produce accents. This painting is a fine example of how dabbing can bring a picture to life. The colors were first laid in with a texturing approach, but the water in particular did not have the shimmering effect I was after. I sprayed the entire pastel heavily with fixative, then went directly into the water with dashes of ivory and other colors, which created a sparkling effect. Throughout the rest of the painting I added dabbed color here and there to unify the composition and bring out accents. For instance, notice how the red headdress of the central figure stands out because of the small dabs of color accenting it.

AUTUMN HUES, *granular board, 24" × 36" (61 × 91 cm). Collection Dr. Winston Cameron.*

Dabbing is ideally suited for painting a scene like this. After establishing the general tonality, I developed the foliage with a seemingly infinite number of dots and dashes of color. The technique is very time-consuming, but the results can be quite effective and well worth the effort.

shadows experienced so frequently in nature . . . a shimmering union of color and chiaroscuro, warm and cool neutrals that are vibrant rather than inert."

The dot was the perfect means to achieve this end. Bernard Dunstan, author of the insightful book *Painting Methods of the Impressionists*, writes: "Only if one attempts to use the dot does one realize the attraction of being able to add touches of infinitesimal amounts all over the canvas, in sparse flickerings here or denser clouds there, according to the amount of modification needed."

Pastel crayons are ideal instruments for applying dots and dashes of pure color. In practical use, however, a purely pointillistic method can be quite tedious and time-consuming, and I find that it is sometimes monotonous looking too. However, when combined with broad color areas, it is a dazzling method.

BLENDING

In my obvious enthusiasm for the many fine attributes of optical mixing, I hope I have not given the impression that blending has none and should be avoided. On the contrary, blending is an extremely useful and integral part of pastel technique. Colors that are gently blended have a soft, velvety, even translucent quality. The tones are expressive and perfectly suited for recreating atmosphere and mood effects. Blending is an easy way to de-emphasize, soften, or mute overstated shapes and colors or to delicately fuse one form into another. It is indispensible for coloring large areas and evening tones in the underpainting. With all these marvelous attributes and more, why does blending have such a bad reputation? The answer is fairly simple—it is the *only* method many artists employ and it is usually done badly.

Before we go on, let me clarify exactly what I mean by blending. Optical mixing is a form of blending, but the colors blend in the eye. Surface blending primarily refers to the rubbing or smoothing together of colors to create even tones

I employ a lot of blending in my pastels, especially in the early stages, but rarely use it exclusively. I believe that blending is more attractive when it is complemented by broken color. This painting shows how I combine the two effects. It was done on location at a very transitory time of day. The colors in the painting evolved along with the changes of color in the atmosphere, and I blended and fixed the pastel between each stage. Although I had not originally planned to, I could not resist finally putting the sun in and then scumbling cadmium yellow lightly throughout the picture. After that I gently blended all the colors with a soft brush to produce the hazy atmosphere and finished the painting with accents of textured and dabbed color.

ick

G SUN, *granular board, 14¹/₂″ × 19¹/₂″ (37 × 50 cm). Collection Wallace V. Mann.*

and gradations. It can be done with a variety of instruments including the fingers and thumb, stumps, tissue, chamois, rags, and brushes. Fingers seem to be the favorite, but blending with them should be avoided when possible because oils in the skin can muddy the colors. (Rubbing may also force pigment into the pores of the skin.)

Although blending usually dulls the colors, the key word here is *usually*. It is tempting to over-generalize when the negative result is so prevalent, but blending does not inherently dull colors. This can be demonstrated with a simple experiment. Pick out two intense primary pastel colors—perhaps a red and a yellow. On a sheet of gray paper, place a square of each color side by side, overlapping very slightly. Then with a soft brush, gently blend the colors into each other. The red becomes red-orange, and the yellow becomes yellow-orange. Most important, however, the mixtures seem just as intense as their component colors. The problems arise when colors are blended indiscriminately. Blending is subject to the same laws as colors mixed on a palette. As long as analogous or two primary colors are blended, the tones will be rich, but if complementary colors are blended, the result will be dulling. Try the same experiment with complements such as yellow and violet. You will see clearly that both colors muddy each other.

Ultimately, the blame for muddy color must rest with the artist rather than the technique. Rosalba Carriera and Maurice Quentin de la Tour both blended extensively, and their colors were fresh and bright. William Merritt Chase is a more recent master who incorporated substantial blending in his pastels, yet his colors never appear dirty or overworked. When employed with discrimination and sensitivity, blending can be quite beautiful.

Blending was especially useful in this picture. After the general color scheme was established and blended to a veil-like appearance, the forms were built up solidly with a texturing technique. Pale grays were then scumbled over the background and partially into the foreground figures and objects. They were then blended just enough to soften the textures and to make the smoky air that enveloped the canemill more convincing.

SYRUP MAKERS, *granular board, 28" × 38" (71 × 97 cm). Collection Mr. and Mrs. Ben Rogers, Jr.*

SCUMBLING

This oil painting term can be quite appropriately applied to pastel. In pastel usage, however, it has a somewhat broader meaning. Essentially, scumbling is the application of an opaque color over a color area, in a thin or broken manner, so that some of the undercolor shows through. In oil painting, a lighter color is scumbled over a darker color, but this is not a rule with pastels. The purpose is far-reaching; scumbling can blur edges and veil forms, subdue harsh tones or enliven dull tones, lighten or darken tones, cool or warm tones, and blend or merge one form into another. All this may be done in specific areas or throughout a painting to create subtle harmonies, unity, and refinement.

In oil painting, scumbling produces a semi-opaque filmy layer not unlike scum—hence the name. It is done by scrubbing the color on with a stiff brush over a dried paint film. With pastels, a skimming or light stroking technique generally is employed to minimize smudging of the underlayers. However, smudging is not necessarily unde-

Scumbling. Here color is scumbled on a toned ground for a gradated effect. It is done with a skimming back and forth stroke of the side of the crayon to produce a gauzy pastel film. The result represents a kind of fusion of texturing and blending techniques.

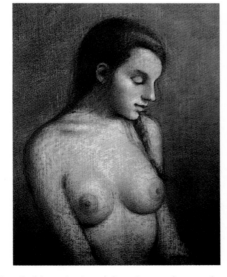

Before. I had considered this painting (above) complete and set it aside. Upon studying it later, however, I began to feel it needed a color transfusion.

After. Scumbling was the ideal solution, as I could make the changes without losing the forms underneath. I warmed the flesh with a rosy pink, then scumbled olive green into the shadows of the flesh. This complemented the warm flesh so well that I continued the green into the background. I skimmed the flesh with a little orange and yellow, then strengthened the highlights with ivory. The subtle intermingling of the colors produced a soft luster and a translucent quality.

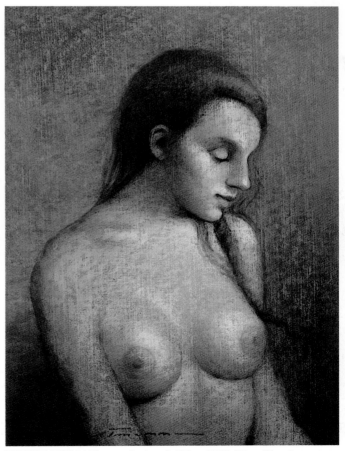

YOUNG WOMAN, granular board, 15" × 11½" (38 × 29 cm).

sirable. To a limited extent, it is a type of delicate blending and blurring that may produce a desired effect. The side stroke normally is the most effective for scumbling. It may be applied with slow controlled pressure or with a gentle scrubbing motion to carefully modulate the tones.

The texture of the ground plays an important role. Color strokes are fractured in various degrees depending on how rough the surface is. This subtle intermingling of the colors that result creates a soft luster and almost translucent effect that is quite appealing.

Scumbling is closely related to the texturing technique described on page 55. However, texturing implies a pure form of optical mixing, whereas scumbling purposely incorporates both optical and blended effects. In common usage, however, the terms are sometimes used interchangeably.

FEATHERING

This term was invented by pastelists to describe the delicate stroking of pastels to produce an effect that somewhat resembles the closely arranged parallel barbs of a feather. Its purpose is similar to scumbling, but instead of employing the side stroke, it uses the tip of the pastel exclusively. It is particularly suitable for subtle refinements, gradations, and harmonizing. The somewhat translucent result is probably the closest we can come in pastel to duplicating a glazing effect. Hard pastels

Feathering. The gradation is executed here with very fine linear strokes. The secret to feathering is to apply each stroke with such a soft touch that the lines are barely discernible and the result appears more like a thin veil of color.

and pastel pencils offer the most precise control, but soft pastels may be used as well with a little more care. In any case, it helps to have a fairly long stick of pastel in hand. Feathering is done by holding one end of the pastel loosely so that you have a lot of leverage and room to swing it back and forth in a scribbling motion. You can use a mahlstick or the tip of your little finger to support your hand. Basically, the tip of the pastel is gently scrawled against the surface in very fine closely spaced or overlapping hatching strokes. The secret is to make each stroke so delicate that it barely makes a discernible line but collectively makes a thin veil of color.

Feathering is particularly valuable in portrait work for making refinements, especially when working on a very rough surface. If, for instance, the flesh tones become too broken, feathering can be used to soften and harmonize the tones without destroying the luminosity of the colors. It can also be used for subtle overall alterations. Suppose, for example, that the flesh tones are too pink or ruddy and perhaps the shadows are too harsh. By carefully feathering an ochre or raw sienna pastel across the entire face, you can neutralize the ruddy complexion and impart an overall delicate golden sheen. In addition, harsh shadows can be softened and harmonized with the light flesh tones—all of this without losing the forms underneath.

LAYERING AND SHADING WITH FIXATIVE

Fixative basically serves three functions: it helps bind the pastel pigment to the surface; it imparts extra tooth; and it darkens the pastel tones. When these effects are carefully controlled, they are invaluable in building up layers and in shading pastel tones.

Layering

The principle of utilizing fixative to help build up pastel layers is relatively simple. Whenever the tooth of the ground becomes filled with excessive pastel pigment, overlaid strokes tend to slide across the surface and smear. Fixative helps remedy this by gluing the pastel particles more securely to the ground and partially encasing the particles in a hard resin film that imparts more tooth to the surface. Additional layers of pastel can then be superimposed with little disturbance of the underlying colors.

This possibility casts an entirely different outlook on the common perception of pastel; it need

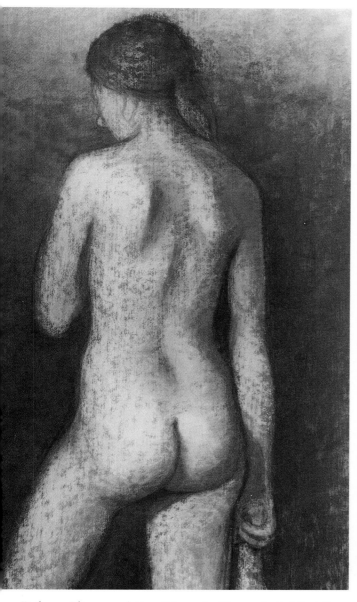

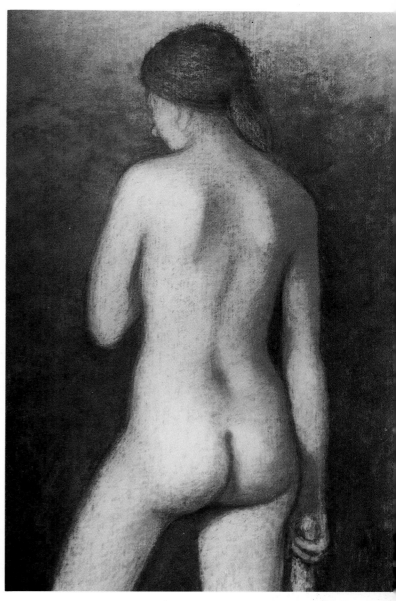

Before. *After completing this nude, I began to feel that the textured surface of the skin was too irregular and gave the flesh an unattractive pitted appearance. I ruled out scumbling because it employs the side of the pastel and therefore could not fill in the pitted effect. I also felt that blending would remove too much of the color. Feathering presented the ideal solution because the fine linear strokes could fill in the dark pitted areas without destroying the forms.*

Detail **NUDE HOLDING CLOTH,** *granular board, 30″ × 20″ (76 × 51 cm). Collection Dashelle Cashion.*

After. *Basically, I feathered a combination of ivory, ochre, pink, and pale blue-gray over the figure. Not only did this even the pitted effect, but it also increased the luminosity of the flesh and gave the colors more of a translucent quality.*

Shading with fixative. *This gradation was made entirely with the controlled spraying of fixative. One color was applied evenly across the surface. The far left was then sprayed heavily, making it much darker. The gradation was accomplished simply by gradually decreasing the amount of fixative; the far right received no fixative. The effect allows the artist to make subtle value transitions with little effort.*

not be limited to sketches and thinly painted pictures. On the contrary, the use of fixative allows a pastel to progress in isolated stages (layers), which facilitates impasto, and gives the medium a range of depth and translucency comparable to that of traditional wet media. Even with the use of fixative, however, most pastel grounds (except extremely rough ones) eventually reach a point of saturation when the surface will not accept more pigment without being overworked and smearing. The noted painter Aaron Shikler aptly calls this being "locked out" of a pastel. The roughness of the particular ground and your own experience will tell you how much layering you can do before reaching this point. Even if you misjudge, a little ingenuity can help you salvage the pastel. Several methods for adding new tooth to the surface are described in detail on pages 72–73.

Shading

Although the darkening caused by fixative is ordinarily considered a negative effect, it can serve two beneficial purposes. First, when it is sprayed across the entire surface, it darkens all the tones in the pastel evenly. (The degree of darkening, of course, is controlled by the amount of fixative applied.) This allows the artist to be bolder in developing forms and lights in intermediate stages, knowing full well that the fixative will push the value scheme back (darken it) to the most favorable values for additional layers and highlights. Second, the fixative can be controlled with spot spraying and masking to darken specific areas and to create fine gradations. Suppose, for instance, the shadows on one side of a face and the hair in a portrait need to be darkened, or perhaps part of the clothing or the background is too light. With spot spraying, the tones can be subdued and gradated—thus allowing the most precise control of the value tones. The process is so fast and simple that it almost seems too easy.

IMPORTANCE OF A TONED GROUND

The usefulness and necessity of a toned ground are virtually undisputed in traditional painting. Try this simple experiment to understand why. Take several light pastel colors—perhaps a pink, an orange, and a blue—and make separate strokes of each, first on a sheet of white paper, then on a sheet of medium gray paper. Now squint and

identify the values of the strokes on the white paper—surprisingly, they appear to be dark. Look at the gray paper and the same color strokes appear to be light. This demonstrates clearly that it is impossible to make accurate value judgments when colors are placed against the overpowering contrast of a white surface. When they are placed on a middle tone, however, a true representation of relative lightness and darkness can be gauged. Study the two sheets of paper again and you will notice another interesting effect. The colors on the gray paper appear to be more vibrant and brilliant than the same colors on the white paper. The tremendous contrast of the white actually diminishes the intensity of the colors, whereas the neutral gray complements the colors. These are the reasons most oil painters mix their colors on a gray or brown palette. Likewise, it is also generally a wise practice to choose subdued colors for toned grounds because intense colors would compete with or even overpower many of the superimposed colors.

Additionally, because pastel is a dry medium and is dragged on top of a surface, some of the color of the ground is likely to show through. If the ground is white, the effect is disrupting, but if the ground is toned, the color actually has a unifying and harmonizing effect on the composition.

MODELING FROM DARK TO LIGHT

This has been the dominant approach to oil painting since its development around the fifteenth century. For many of the same reasons it works so well for oils—along with some reasons peculiar just to pastels—modeling from dark to light is also by far the most advantageous approach to pastels. Some of the reasons for painting from dark to light were previously discussed under the importance of a toned ground. The following reasons also support the merits of this approach.

The Logical Progression

Fine painting is a complex process that requires logic in order for the painting to flow smoothly and achieve the best results. The construction of a house provides a good analogy. One does not install the carpeting before the walls are plastered and painted—or the roof put on. Yet this is essentially what many artists do in painting. They practically start a picture with what should be the finishing touches—highlights, fine details, impastos, and so on. The result, not surprisingly, is confusion and frustration.

Drawing serves as the basis—the foundation—for the construction of forms and compositions. In the most elementary way, line and value (the essential elements of drawing) can define the character and structure of all forms. Instinctively, artists have always drawn with dark lines and values on light surfaces, basically modeling forms from dark to light. This seems to be the most natural and logical way to proceed.

Advancing and Receding Planes

Try to think of modeling forms also as a process of defining space: that which recedes and that which advances. Lines can give some illusion of this, but value—and, to some extent, hue and intensity—has a far greater potential for creating the illusion of depth. Relatively speaking, dark, cool, and subdued colors appear to retreat, while light, warm, and intense colors appear to advance. The fact that warm, intense colors are more frequently those of light (illumination) and cool, subdued colors those of shadow only reinforces the impact of the illusions.

Values exist in infinite gradations from dark to light, but for the sake of simplicity and organization we think of values in groupings of dark, middle (half), and light tones. A middle or half-tone is the most desirable value for a toned ground. Essentially it represents a flat plane that exists halfway in our perceived measurement of depth. The modeling process is greatly simplified if we can concentrate on moving one direction from that plane at a time.

Begin by laying in the darks and cooler, subdued colors of the composition, basically establishing the retreating planes. Then slowly begin to advance. Intensify the middle tones and gradually get lighter and warmer, finally stating the lights that advance the most—the highlights. Keep in mind that white will project the most forward and black will recede the deepest. If either value is used in large masses, a flattening of the planes will result, because accenting is for all practical purposes nullified. It is virtually impossible to highlight a white surface or create a dark accent on a black. Therefore both white and black are more effective if they are reserved only for accenting.

Another aspect of creating the illusion of space is the perception of depth that paint quality displays. In most cases, darks appear to recede deeper into the picture plane and are more colorful when they are applied thinly and translucently. If light, thick, opaque colors are applied first, it becomes much more difficult to achieve

depth and luminosity in the darks. The white pigment in the pastel acts like wet paint and intermixes with the darks, giving them a chalky and flat appearance. On the other hand, light colors are generally just as intense when opaque as when translucent, and in fact they seem to advance more when they are applied thickly. Logically, then, the best procedure is to establish all the darks first with thin, translucent applications and to move forward gradually in a crescendo of lighter and thicker color. The culmination of impasto lights on top of thin translucent darks results in a convincing sense of depth.

Edges

The dark-to-light modeling approach makes it easier to control the sharpness or blurriness of edges. The secret is to expand the darks slightly beyond their boundaries or to make them a little larger than their actual size, then refine their shapes by applying the middle tones over the rest of the surface, nudging them into the darks, and finally

Defining edges. This diagram demonstrates the way edges are defined in a dark-to-light modeling progression. The four spheres were drawn in with charcoal lines, and the dark tones were laid in so they extended over the lines into the light areas. Therefore, when the lights were overlaid on the spheres at the right, a slight blending of the two tones occurred and resulted in soft, somewhat blurred edges. The resulting emphasis is on the three-dimensional nature of the forms rather than the edges themselves. Soft edges appear to recede and fade gradually into the background, whereas hard edges command attention.

The dark and light stripes also demonstrate this. On the left side the light overlapped the dark, creating a blurry edge that appears to turn. By contrast, the crisp edge on the right flattens the tones and emphasizes the line between the two. Both types of edges serve a purpose, and it is important to understand their results so you can use them to a painting's advantage.

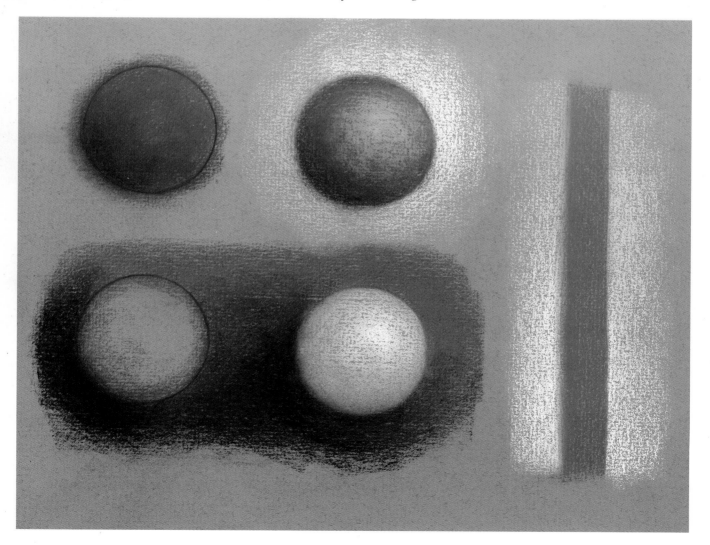

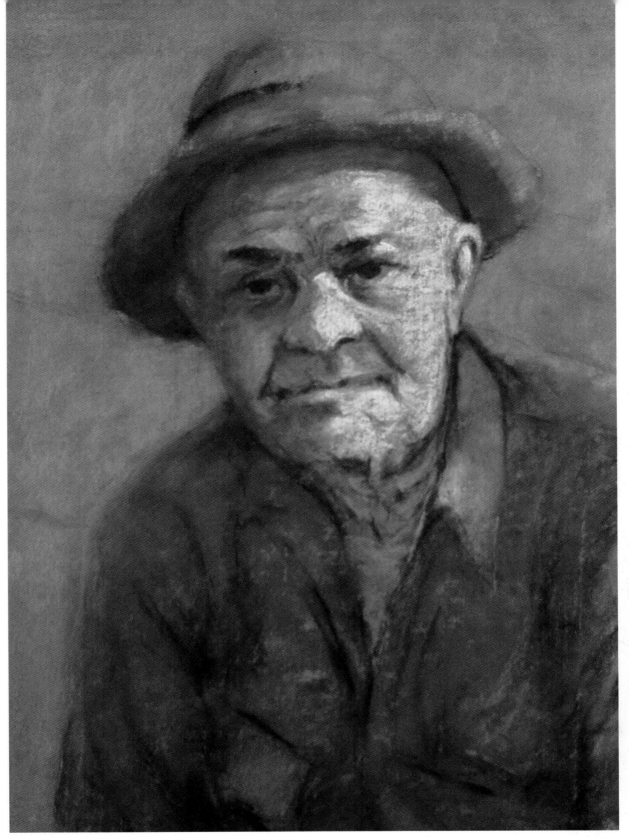

Detail **MR. BOOTH,** *granular board, 24" × 18" (61 × 46 cm).*

The edges in this portrait are purposely soft and indistinct. The shoulders and hat almost evaporate into the background. Only the face has strong contrast and definition. This combination of hard and soft edges helps create a sense of form and space and connects the figure with the background. This selective focusing also allows the artist to orchestrate the composition—moving from quiet, soft passages to crescendos of greater contrast and clarity.

laying in key areas of light, which are gradually enlarged and refined. This progression enables the artist to produce either hard edges or soft hazy edges every time the values are overlapped. However, if the values are laid in edge to edge, the result is always harsh and unnatural looking. Usually a varied handling of edges is the most advantageous and interesting. A slightly blurred edge is really the most natural and effective in duplicating the appearance of receding and turning edges. Unless we are consciously focusing on a particular edge or line, it is difficult to see sharp edges in nature.

MAKING CORRECTIONS

Everyone is entitled to make mistakes and have second thoughts, and sooner or later you will need to rectify something that has gone wrong in your pastel. Minor problems can simply be covered up with more pastel, and no one will ever be the wiser. Constant modification and adjustment are the nature of the medium. Trying to cover up serious problems, however, usually leads to overworking. In these cases, the best way to make a correction is to remove as much of the problem as possible and start fresh.

Removing Pastel Layers

Pastels cannot be erased in the usual way by rubbing; all this does is smear the colors and make a bigger mess. Rubbing also flattens out the texture of papers and leaves annoying eraser deposits on grainy surfaces. When pastel has to be removed, first try scrubbing the area with a stiff bristle brush. The bristles will dig deep into the pigment and lift most of it off without injuring the surface. The flat edge of a razor blade gently scraped across the surface also works well in many instances. Spray the area with fixative and it is ready to paint on again. If neither of these methods removes enough color, you might be able to take some more off with a kneaded eraser—but do *not* rub the surface with it. Instead, press the eraser firmly against the surface to lift additional color without any smearing. Repeat the process as many times as necessary, but remember to clean the eraser by kneading it well between every application.

Perhaps the easiest and most effective way to lift off color is to press the sticky side of masking tape against the surface. When it is lifted, quite a lot of pigment will come with it. Repeated applications with fresh tape will remove nearly all the color. Another method you can try is to spray a wad of cloth with fixative and dab the surface with it. This lifts the color from grainy textures particularly well, because the cloth can compress into the crevices.

If the pastel support is fairly sturdy, sometimes simply washing the unwanted color off is the best method, especially if it covers a large area. With a sponge dampened in water or turpentine, begin to wipe away the pigment. Keep rinsing the sponge and wiping until the color layer is removed. You might even decide not to remove all the color. Wetting and wiping the pastels blends them into an even muted tone and underpainting effect that might be perfectly suited to your purpose.

Regaining Surface Texture

The most common problem with attempts to make corrections and changes is overworking, which results in muddy or chalky color and damage to the surface texture. Once the unwanted color is removed, the texture may need to be repaired or replaced before new color can be applied. The remedy can vary somewhat with each surface, but the initial one to try is simply to spray fixative on the damaged area. Crystal-clear acrylic spray actually imparts more tooth than workable fixative and will usually render the surface serviceable again. If it does not, more serious steps must be taken.

Texture can be created on paper surfaces by raising the grain with sandpaper. The sandpaper roughens the paper fibers and produces a fuzzy surface that takes pastel well. Be sure, however, that this effect is compatible with the other textural effects in the picture. You might consider sanding various areas to harmonize the effect. Experiment with different grades of sandpaper to determine which works best.

Although it is unlikely for the rough surface of a handmade granular board to become so damaged that fixative alone would not restore it, it can happen, and there are two remedies. The first requires making a small batch of the formula for toned granular boards (see page 31). After scrubbing off as much of the unwanted pastel layer as possible, carefully brush the paint and powdered stone mixture onto the damaged area. Make the brushstrokes the same direction as the strokes in the original ground and feather them into the surrounding areas. The result is a duplicate of the original ground.

The second procedure is more drastic because it usually requires reworking the entire pastel. It involves sprinkling powdered stone (usually pumice or marble dust) over the damaged area

and spraying it with fixative to secure it. The result is a grainy texture capable of holding much color. The procedure can be employed on other surfaces besides granular boards, as long as they are fairly sturdy. However, once the stone is applied to one area for repair purposes, it must be integrated into other parts of the composition for the sake of unity. The texture is so pronounced that, if isolated, it will appear very foreign.

Start by laying the painting face up. Put some of the powdered stone in a small, fine-mesh strainer (a salt shaker might also work well), and gently sift it over the damaged area. Let the powder overlap the adjoining areas and gradually taper it off. Then sift more powder over other areas in the picture that seem appropriate. Next spray the powdered stone with successive heavy coats of crystal-clear acrylic fixative until it is dampened.

Stage 1. This small landscape was started on location. Midway into it, I attempted to change my original design concept rather drastically and ended up overworking and muddying the colors. Back at the studio, I decided that I had to discard the picture or do something dramatic to improve it. This photo shows the picture after I had scrubbed most of the color off, getting back to the original drawing as much as possible.

Stage 2. I laid the picture on the floor and sifted pumice over it, concentrating most of the pumice in the light areas. I sprayed it with heavy successive coats of an acrylic crystal-clear fixative until it was dampened, then picked up the pastel and tapped it sharply from the back to dislodge any loose pumice powder. I sprayed it once again to thoroughly secure the new grainy pumice tooth.

MORNING HAZE, *granular board, 14¹/₂″ × 19¹/₂″ (37 × 50 cm).*

Stage 3. The painting was completed from memory with a much clearer concept of design and mood quality. The sprinkled pumice not only added new tooth but also created a much stronger impasto effect.

Pick up the pastel and tap it sharply on the edge or from the back to dislodge any loose powder. Again spray more fixative until the powder is well secured. This whole process may be repeated to get even more tooth.

Rather than employing this process only as a remedy, you might want to incorporate it into the pastel as a planned practice. The rough texture of the powdered stone lends itself to creating very heavy impastos and other appealing effects. However, since the addition of the powder is so prominent, it is wise to introduce it before the pastel is advanced or near completion.

ACHIEVING GOOD COLOR

How do we determine what "good color" means and by what criteria it is judged? Can we assume, for instance, that Monet was a better colorist than Rembrandt because he used more colors in his paintings? Of course not; both artists were great colorists for different reasons. Monet chose the entire spectrum as a palette in his quest to paint the radiant effects of sunlight. Rembrandt, on the other hand, was more fascinated by the mysterious chiaroscuro of twilight and found that the friendly colors of gold, brown, and red best suited his purpose. If good color has no relation to the number of colors used, is it the intensity of the colors that counts? Again the answer is no. Whistler was also a master colorist, but his paintings are limited to grays, browns, and other subdued colors. Good color is therefore judged not by colorfulness or intensity, but by how well the colors function within the context of each painting. To determine this, we must ask the following questions:

Are the Colors Appropriate?

Color selections must be consistent with the emotions and atmosphere that the artist wishes to present. The delicate low-toned color harmonies of Whistler's paintings would certainly lose their charm and reserved elegance if painted in the sparkling and intense colors of a typical Monet canvas. Conversely, a Monet landscape would lose its radiant atmosphere and vibrancy if painted in the subdued tones that Whistler used. The solemn, spiritual feeling evoked by Rembrandt's religious themes would not be as effective if painted in anything other than the golden tones he favored.

Each place, season, time of day, weather condition, source of illumination, and mood quality summons to mind a different set of colors. These conditions are both observed and subjective, and each artist may have a different interpretation and feeling. Nevertheless, the effectiveness of the artist's expression relies on continuity and clarity, which the masters understood and carried out to perfection in their compositions. When these qualities are not present, confusion results.

Are the Color Combinations Harmonious?

Color harmony is the result of a balanced relationship among the three dimensions of color: hue, intensity, and value. Essentially, it is the unifying force of composition and nature. Dissimilar objects such as sky and earth are related because dimensions of some of the same colors are repeated in each. The blue sky reflects on the earth, floods its shadows, and is mirrored in its waters. The earth in turn reflects back into the sky, warming and modifying its hue. Both are then infused with the golden glow of sunshine. This accounts for the constant variety and harmony of nature's colors that make them so fascinating to study and imitate.

Color harmonies may be divided into two classes: first, colors that are similar, so that one general tonality pervades the combinations, such as the analogous color harmonies of the paintings of Rembrandt and Whistler, and second, colors that are very different in hue, so that there is a balance of contrasting colors, such as the complementary color harmonies in Monet's work. In these color harmonies and their variations, unity exists when there is a dominance of one color, either in a large area (in a single place or as an overall tonality) or in a smaller area where the color is of great intensity. If one color is not allowed to dominate, the colors will clash and be discordant.

Are the Colors Luminous and Vibrant?

When applied with understanding and sensitivity, *all* colors can emit light and life. Even dark, grayed colors can be luminous and vibrant. By contrast, if colors are overworked or laid in haphazardously, they may have a muddy, smeary, and chalky appearance. They may lose all sense of translucency, luminosity, and vibrancy. The following suggestions may help you to create pastel paintings that are luminous and vibrant in color, but remember they are simply guidelines—not rules.

Build up colors with overstated intensity. After the preliminary drawing and basic color lay-in are established, begin immediately to build up tones

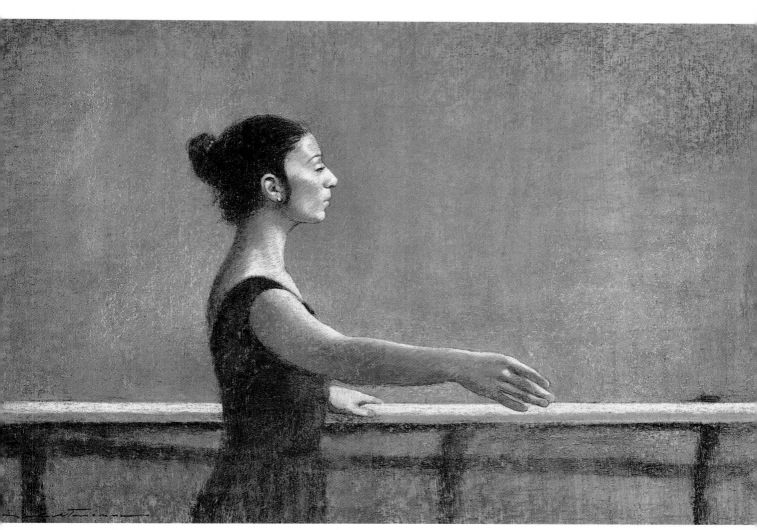

BALLET PRACTICE, *granular board, 18¹/₂″ × 28¹/₂″ (47 × 72 cm).*

This painting is an obvious example of analogous color harmony. The pervading tonality is burnt orange and the lights are yellow-orange and gold—all closely related colors. Some olive green is intermingled, but it is subdued and serves as a subtle complement and modifier to the dominant warm tones. These colors were chosen to infuse the scene with a sense of late afternoon sunlight radiating through an open window. I believe the close color harmony also contributes to the quiet, contemplative mood of the subject.

VIEW OF FRENCH MARKET FROM LEVEE, CIRCA 1885, *granular board, 26" × 34" (66 × 86 cm). Collection Mr. Joseph F. DiMaria.*

Here is an example of a very simple complementary color harmony. Large masses of subdued oranges, reds, and yellows are complemented by blues and cool grays. The warm and cool tones are played against each other in a decorative manner, but the warm tones are allowed to dominate. The scene was based on some photos taken of New Orleans in the late nineteenth century. I chose these colors because I somehow associated them with the rustic nature and charm of that period.

with colors that are more intense than you think are needed. It is very easy to quiet colors at any stage of a pastel's development, but it becomes increasingly more difficult to intensify colors without overworking them as the pastel painting progresses.

Maintain color purity as much as possible. A normal flesh tone, for instance, might consist of variations of pink, red, yellow, beige, green, and brown. Pick out the appropriate colors and lay in the tones like a patchwork of separate colors. After the forms are boldly modeled, the tones can be gently fused and softened to the desired gradation. This method not only results in purer tones and greater brilliancy, but also forces the artist to model with hues as well as values.

Paint shadows with hue as well as value changes. Remember that shadows have their own color character and are not just darker shades of local colors. The assumption that they are alike is the direct cause of many uninspiring color schemes. If they were, the simple addition of black or neutral gray would produce the correct shadow color. Instead, it only dulls or muddies the colors. Generally, shadows are cooler than and complementary to the local colors—but reflected light and other factors also may affect them. Observe shadow colors with particular care, and do not hesitate to put in whatever colors you see.

Paint light areas with hue as well as value changes. Like shadows, light areas change in hue as well as value. The addition of pure white to lighten colors only dulls them and gives them a chalky appearance. Lights are generally warmer or more yellow in appearance. Even in the final highlights, white with a very slight yellow tint will usually appear more brilliant than pure white.

Create groupings of similar colors. We have already discovered that broken colors of similar hues reinforce each other's brilliance and broken colors of complementary hues neutralize each other. This clearly tells us that groupings of similar colors produce the most intensity. We also learned that although complements neutralize each other when broken or juxtaposed in relatively small spots, when placed next to each other in fairly large areas, they complement or make one another appear more brilliant. Basically, the same principle also applies to color groupings or areas. For instance, a green area composed of broken yellow, green, and blue will intensify a red area composed of broken violet, red, and orange. However, if all these colors are juxtaposed, they will neutralize one another.

Blend by rubbing sparingly and cautiously. The apparently uncontrollable urge to blend colors by rubbing is without a doubt the biggest cause of muddy color in pastels. After initial blending to even tones, be selective about the areas you blend this way. Particularly avoid rubbing complementary colors together, which can become very dirty looking. In general, scumbling or feathering will blend colors sufficiently without destroying their vibrancy.

Beware of the limits of surface texture at all times. This advice may sound like a broken record by now, but it is probably the most critical factor in pastel. Overworking and the resultant effects of muddy or chalky color usually result from loss of surface texture. Plan the development of the pastel according to the layering limits of each particular surface.

One final note. This chapter has emphasized the careful observation and imitation of color changes in nature, but this does not mean that the artist is simply to copy nature slavishly. The joy of painting, after all, is self-expression. Nature is the ultimate teacher and the definition of perfection, and any small discovery about its wondrous ways can give us insight into how to make our own miniature creations more viable. Even if working in a totally nonobjective style, we can find inspiration in the study of nature's eternal order.

STRUTTIN, *granular board, 28″ × 20″ (71 × 51 cm). Collection Mr. and Mrs. Merrill Harris.*

CHAPTER FIVE

Pastel Painting Techniques

The term *technique* is used here simply to define the orderly way in which a painting is developed—regardless of style.

Painting is a complex process involving many aesthetic and technical problems that when considered simultaneously, can be overwhelming. Dividing the task into a systematic procedure, however, allows the artist to deal with one problem or phase of the painting at a time, thereby greatly simplifying the task of painting and making the most complicated problems solvable. By having a plan, the artist is actually freed of many of the technical worries and can concentrate on the more important aesthetic considerations.

BASIC PROCEDURE

Pastel painting techniques are influenced by many factors, including surface texture, additional media, subject, and painting style. However, the basic procedure is essentially the same for every technique and follows these general stages:

Employment of a toned ground. The purpose and importance of a toned ground were emphasized in Chapter 4. If a surface is not already toned, it is essential that a tone be applied. Usually the tone is applied first, but in mixed-media techniques it is sometimes applied over the drawing. It is usually a middle tone, subdued and of one color, but these characteristics are subject to variations.

Blocking in and construction of the drawing. Many artists are so eager to get to color that they hurry through this stage, which may be the most crucial part of a pastel's development. A good drawing is a good plan and helps the painting to proceed expeditiously. If extensive redrawing and correcting must be done late in the painting, the struggle

will probably result in overworking and end up taking more time in the long run.

Whether the subject is a portrait, figure, landscape, or still life, the forms should be conceived initially as large abstract or geometric shapes. Block in the whole forms first with simple lines. Consider the placement and relative size of these shapes as they relate to the overall composition. At this stage it is easy to experiment and maneuver the shapes to get the most pleasing arrangement. Construction then proceeds to refinement of the larger divisions of the forms and finally to the smaller parts and details.

To keep the construction under control, avoid using hard lines at first. A light, sketchy line allows for easy adjustments. Above all, do not complete any one part of the drawing until you are sure that its location and size are correct and until the whole composition is at least roughly blocked in. The degree of refinement and shading of the preliminary drawing varies considerably from technique to technique and with the temperament of individual artists. I will make specific recommendations, but these are also subject to variations.

Color lay-in. This is the initial stage of coloring that goes over the drawing and toned ground. The purpose is to establish the overall color scheme in a loose, simplified, and somewhat low-key manner. The entire surface is covered quickly with semi-opaque, light pressure strokes, much like laying in washes of color in an underpainting. As a starting point, the local and shadow colors of each object are laid in with the broad side of the pastel crayon, but these colors serve simply as a point of departure. The design is more important than precise color reporting. Feel free to experi-

ment and be expressive. This stage sets the direction of the final color scheme and changes can be made easily. Nevertheless, limit the colors primarily to middle tones and darks; do not use strong lights in the lay-in.

This is the only time when I generally recommend overall blending by rubbing or brushing. After the color lay-in is complete, gently fuse the edges together and soften the tones with a wide (1½" to 2") brush so that the colors create an overall veil or dimmed soft-focus effect.

The color lay-in may also take the form of an underpainting, which usually implies the introduction of another medium, resulting in a mixed-media technique. However, pastel washes can easily be produced by working into the pastel with brushes and sponges dipped in water or turpentine.

Isolating layers with fixative. This process serves an invaluable function in pastel painting. Essentially, fixative is sprayed between the stages of a pastel's development in order to isolate underlayers as much as possible and keep them from being smeared by new color applications. The drawing and early color stages are sprayed especially heavily. As the pastel nears completion, lighter coats are applied because of the fixative's darkening action. In some cases, fixative may also be used to build new texture by gluing powdered stone to the ground between layers of pastel. This procedure is described in detail in Chapter 4.

Color buildup. The body of the pastel is built up in this stage, which may be divided into several steps depending on the roughness of the surface texture. Pastel is now applied with heavier pressure and more intense colors. Because the darks should be kept as thin and translucent as possible, concentrate on strengthening the halftones and gradually building toward the lights with thicker, more impasto applications.

Finishing. This is a crucial and distinctive stage. The forms and composition are already well developed, and at this point everything seems to crystallize and come alive. Finishing is the delicate process of fine-tuning the composition to achieve the best possible balance, unity, and control of emphasis. To accomplish this, you may need to soften some edges and sharpen others; subdue some areas and intensify others; scrape down pigment here and there and add it in other places.

All in all, it is a very careful process, and you must be cautious not to go too far and end up overworking instead of refining. The finishing touches are the final bits of refinement. I usually spray on a light coat of fixative just before this step. Then I add the final sparkles of light, put in the deepest accents of dark, and add tiny accents of pure color where appropriate.

BASIC TECHNIQUE VARIATIONS

The range of styles and effects in pastel is unlimited, and not every possibility can be covered here. However, the majority of the desired results can be achieved by using three slightly varied techniques, all of which conform to the basic procedure already described. The differences result primarily from the relative roughness of the assorted pastel grounds and the introduction of additional media. They are classified here by their major distinction.

Technique on Fine-Toothed Surfaces

This technique is geared to the fine or delicate textures of most paper surfaces, especially traditional pastel and charcoal papers, as well as some mat boards. It may also be appropriate for very fine granular and fabric grounds. The technique is characterized by these factors:

Colored or charcoal underdrawing. The preliminary drawing (underdrawing) is constructed and modeled with pastel or Conté pencils and Nupastels (hard pastels) in dark color shades such as sepia, umber, sanguine, and olive-green—or with charcoal in shades of black and gray.

This pastel was done at a period when my work was strongly influenced by the Impressionist style of Degas and Cassatt. The blotting paper has an interesting fibrous texture, but I do not know how permanent it is. The main characteristic of a technique on a fine-toothed surface is that the pastel is applied in a minimum number of steps in order to avoid overworking the colors. After I sketched in the subject with a sepia pastel pencil and Nupastel, I laid in the general color tonality with the side of the pastel and lightly blended. Then I developed the forms with short hatching strokes and did very little additional blending. The charm of a work like this lies in the freshness of the color and the vitality of the strokes.

GEOFFREY WITH WATERING CAN, *blotting paper, 24" × 18" (61 × 46 cm). Collection Mr. and Mrs. Gerald Flattmann.*

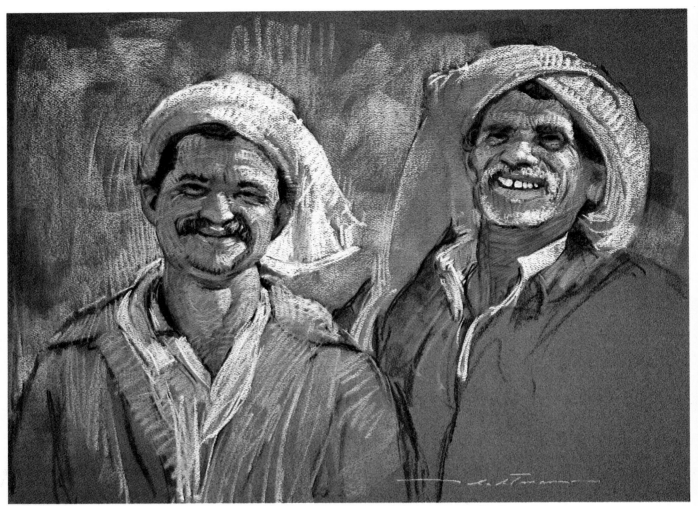

MEN FROM CAIRO, *Canson paper, 17" × 23" (43 × 58 cm). Collection Mr. and Mrs. Thomas W. Crockett, Jr.*

Limited pastel buildup. The fine tooth of these surfaces fills in quickly, and the delicate nature of some requires special care to prevent damage. Therefore the amount of pastel pigment or layers that can be built up is limited and the picture must be completed in a minimum number of steps to avoid overworking. A colored underdrawing expedites this because its hues and shades are easily incorporated into the finished picture.

This technique seems particularly appropriate for works that must be executed rapidly—such as studies or paintings directly from the model or landscape—although it can be employed for more complex works as well.

Technique on Medium to Rough Surfaces

This approach is designed especially for surfaces such as granular or fabric boards, canvas, and the rougher sanded pastel papers. It has three distinguishing characteristics.

When employing a fine-toothed surface, I generally like to work rather loosely and have fun with the pastel strokes. Ironically, I prefer to use relatively rough surfaces for highly refined works because they permit more color manipulation and layering. These two happy gentlemen were drawn in and shaded with a dark brown Nupastel. Then I stroked in the colors very boldly and purposely let a lot of the gray paper and original drawing remain to accentuate the sketchy quality of the piece.

It is hard for me to imagine executing a pastel this large and complex on regular pastel paper. Before any pastel color was applied, the drawing was refined and shaded with black Nupastel. This practice would dirty the superimposed colors on a fine-toothed surface, but on a rough surface it adds depth to the colors without any muddying. It is also much easier to produce detail on a rough surface because areas can be fixed and redefined many times.

Extensive use of black in the underdrawing. The preliminary drawing is blocked in and constructed with line in vine charcoal first. Then it is refined and shaded with black hard pastels (Nupastels) to create an underdrawing of strong overall value. The darks are made very black, the middle tones distinct, and the lights are unshaded—therefore the general effect is rather severe. This is purposely done so that the drawing will show through and add depth to overlaid colors.

Extensive use of fixative. The effects of fixative are more crucial in this technique than in the others. The black underdrawing must be well fixed so that it is not smeared away and does not muddy the overlaid colors. Also, because the rougher surface can hold more pigment, much heavier applications of fixative must be employed.

Strong impasto effects. The pronounced strokes and thick application of pigment that are possible on medium to rough surfaces totally contradict the notion that pastel is a weak, insipid medium. In conjunction with heavy fixing (possibly even to build new texture with powdered stone), the coarse textures allow pigment to be built up in many layers with crispness and sparkling colors.

This technique is capable of producing an overall effect of great depth and brilliance. Suitable for any pastel work, it is especially recommended for large or complex paintings that demand careful development.

THE FRENCH MARKET, CIRCA 1890s, *granular board, 29" × 38" (74 × 97 cm).*

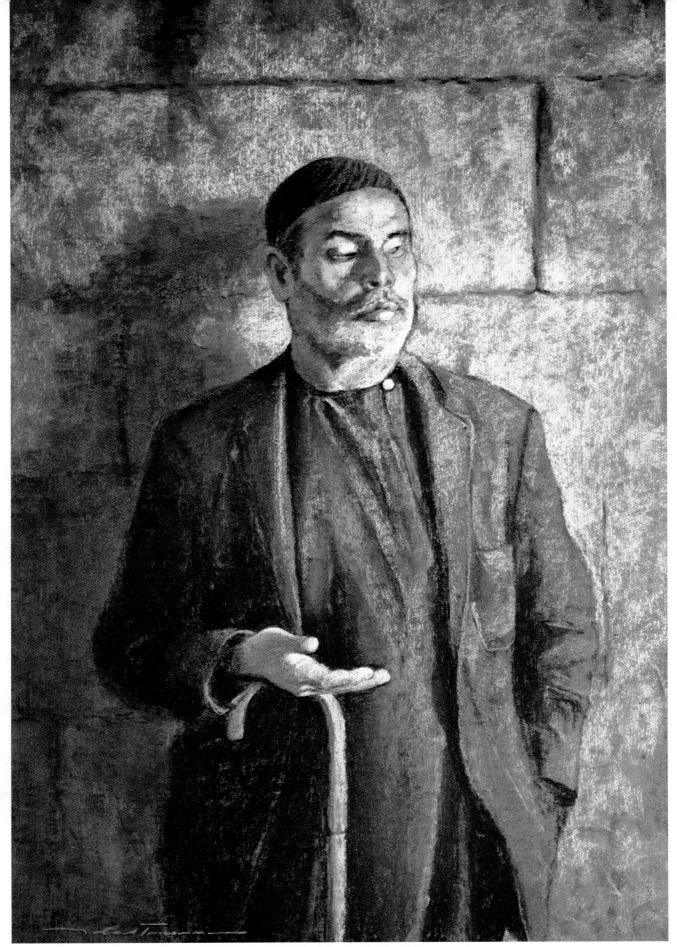

THE BLIND BEGGAR, *granular board, 27″ × 18″ (69 × 46 cm). Collection Mr. Harold Young.*

The rough surface of the granular board practically painted this picture for me. That is, with hardly any effort, it perfectly reproduced the rugged texture of the stone wall and the rugged granite features of the blind beggar from the ancient city of Jerusalem.

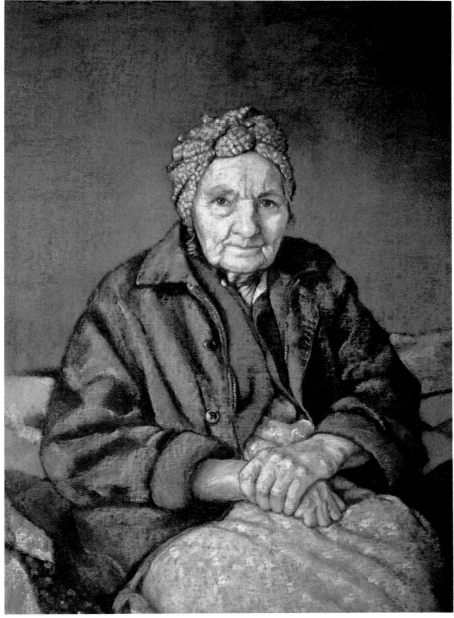

After blocking in with vine charcoal and shading with black Nupastel, I sprayed the drawing heavily with a clear acrylic fixative to isolate it, then wiped on a thin turpentine wash of burnt umber oil paint with a rag. After it dried, I laid in more oil washes of local colors. The mixtures included some white, but I made no attempt to establish any kind of brush strokes. When the paint was dry, I redefined the drawing and began to develop the forms with pastel in a texturing technique. The combination of the two media helped produce a richly varied paint quality and a strong feeling of depth.

PORTRAIT OF ZELLIE, *muslin fabric board, 25" × 18" (64 × 46 cm).*

Mixed-Media Technique

Almost any painting medium can be combined with pastel. The possibilities are endless, and the results can be very exciting and unusual. I have found that watercolor, acrylic, and oil are able to produce all the effects I have tried to achieve, but gouache, casein, tempera, and alkyd are also recommended.

Water-based paints may be used on any surface that will not permanently buckle or warp. Watercolor papers and boards are the most natural selections; lightweight papers are not a good choice.

Fabric boards and canvas are the most suitable surfaces for oil-based media, but any surface may be used if it is sized first to protect the natural fibers from the deteriorating effects of the oil. Fabrics are usually sized with a coat of hide glue or a mixture of half denatured alcohol and half shellac, but thinned acrylic gesso or medium works quite well in all surfaces. Granular boards and sanded pastel papers have sizes incorporated in their grounds, so none extra is required.

The added media are always used in the underpainting—never on top. Their purpose is generally to work out the problems of color and compo-

sition loosely, without concern about filling in the tooth of the ground with pastel. The underpainting also adds depth and variety to the overall paint quality. Its final influence, however, varies according to the way it is employed. Here are the two primary methods:

Transparent underpainting. In this approach, the paint is diluted with a solvent and applied in thin washes over a line drawing sprayed with fixative. The surface must be white or light in value to work. (Note that oil paints should be thinned only with turpentine or mineral spirits—no additional oil should be used!)

The important point to remember is that the washes are meant to be an underpainting, not a finished painting. There is no need to preserve light areas, and in fact it is recommended that the values be predominantly middle and dark tones. Above all, no white areas should remain. Generally, I start by laying on an overall wash of ochre, brown, or gray and then work into it with other colors.

Semi-opaque underpainting. This is similar to the transparent washes except that white is added to the paint and it is applied in heavier, more opaque films. However, I do not recommend building up impasto effects in the underpainting because they might interfere with the pastel application and refinement. The main advantage of opaque paint is that it can be applied over middle- and dark-tone surfaces, instead of white or light tones only.

Although both types of underpainting may be carried to various degrees of development, they serve primarily as an initial color lay-in.

PASTEL PAINTING OR DRAWING?

The critic who has consistently referred to my highly developed, full-color, heavily layered pastels as "drawings" cannot be overly criticized for misusing the term. Ever since pastel was invented, there has been a problem with properly describing what it is. Like many others, he simply has assumed that all pastels are drawings because they are dry and not applied with a brush. Curiously, most people have no difficulty in understanding that oils, watercolor, and other media can be used for drawing—so why the problem with comprehending pastel painting?

Granted, the distinction between drawing and painting can be confusing—especially with a medium capable of pastel's diverse effects. Indeed, this is a large part of its attraction. One can draw

lines with pastel better than with any other color medium, and it produces painterly effects just as easily. Thus, the results must be considered in deciding whether a pastel is a drawing or painting.

Pastel drawing implies the employment of the medium in a rather sparing way. Usually, the palette is very restricted and the colors are limited to shading, highlighting, or decorating and to brief, sketchy passages. The paper or other surface is generally not completely covered, and its color is largely incorporated into the composition. The pastel is basically applied thinly in limited layers, and the overall effect often suggests rather than defines.

In turn, pastel painting is characterized by extensive employment of the medium. A complete tonal range is developed using all aspects of color. All or most of the surface is covered with pigment in successive applications. The result is a variety of painterly effects such as broken color, luminosity, translucency, scumbles, impasto, and so forth. The overall effect is generally one of completeness and solidity.

Although most pastels can be appropriately identified as either drawings or paintings, some of them fall somewhere between the two, defying labeling. I suppose the confusion will continue, and perhaps it really does not matter very much after all.

Pastel Drawing

The purpose of drawing is to capture the essence of a subject in a simplified or shorthand way. It may be used for gathering information or for making studies in preparation for larger, more complex works—or simply for the joy of it. There is a directness and intimacy to drawing that is sometimes lost in the complexity of painting.

Hard pastels (Nupastels) and pastel or Conté pencils are ideally suited for drawing. Almost any surface recommended for pastel will work well for drawing, but my choice is usually charcoal paper, which has a very appealing laid (linear) texture. Again, the toned surfaces are the most useful.

The most expedient method of drawing in pastel is with a restricted palette. Exquisite examples can be seen in the chalk drawings of Watteau, Rubens, Rembrandt and other old masters. The majority are executed in shades of red (sanguine) and black on buff-colored paper, heightened with white. The effect is one of simplicity and economy, but with strong impact.

Numerous color combinations can also be em-

ployed to create equally effective results. The color of the paper plays an important role in the drawing and can suggest other colors. For instance, if the paper is a light beige or brown, one might start drawing with a medium brown, then go to a darker brown and then to a black. With each progression, the drawing can be more refined. Finally, the forms are heightened with an ivory color. Essentially, the result is a monochromatic color scheme with the paper serving as the middle tone and the pastels as light and dark tones.

Drawings do not have to be limited to shades of the paper color. Colors can be related to the subject in a suggestive way. For instance, a palette of sepia, sanguine, ochre, pink, and ivory can produce attractive flesh tones very quickly for portrait studies. For landscape drawings, an olive-green and pale blue can be added to the traditional drawing colors of sanguine, black, and white to produce some surprisingly colorful and natural results.

Part of the pleasure of drawing in pastel is the experimentation and colorful results, but be careful not to destroy the simplicity of the drawing by using too many colors.

On the following pages (pages 88–101), I have used drawings and details and recreated strokes and washes to show how I applied the techniques discussed in the last two chapters to several of my own pastel paintings.

STANDING MALE NUDES, *charcoal paper, 24" × 18" (61 × 46 cm).*

Red chalk drawing dates back many centuries and is still my favorite method of sketching. This drawing was done on Strathmore velvet gray charcoal paper. I lightly blocked in the figures with a Conté sanguine drawing pencil, blended them with tissue, then refined the shapes with more precise lines and values. After removing smudges and unwanted lines, I used an ivory Nupastel for the highlighting. The appeal of this drawing technique is that it is very easy to make alterations, and drawing seems to be more enjoyble with the employment of some color.

"PAINTERLY" BLENDED APPROACH

Pastel can be blended and worked with in a way that gives it an appearance very similar to oil paint. The key to achieving the effect is using very soft pastels and a surface that is relatively smooth yet capable of holding heavy applications of pigment. The only surfaces I have found that do this well are the sanded pastel papers and Pastelcloth.

I especially enjoy using the blended approach and sanded pastel paper for small figure paintings. Very fine detail is possible that would be difficult to produce any other way, yet the technique has so many creative possibilities that it prevents me from getting hung up on the details. The Greek Shepherd has a delicate balance of detail and suggestion that, I think, creates a greater sense of reality than if every detail were precisely painted.

THE GREEK SHEPHERD, *extra-fine sanded pastel paper, 21" × 11" (53 × 28 cm). Collection Charles Hilton.*

"Painterly" blended color. This effect is achieved by applying the pastel in broad strokes and then blending it with a soft paper towel (a small area that is not blended is evident in the upper right). Blending gives the color a smooth, translucent quality and softens the edges. The hard edges and thicker pigment are laid over the blended color with the side of the pastel, using fairly heavy pressure.

Importance of a cushioned drawing board. A smooth, painterly pastel stroke is produced more easily if the pastel paper is on a drawing board that is cushioned with layers of paper or a thin rubber pad. In the example at left, the board was cushioned. The brown was applied in a single stroke, yet very little of the paper shows through. With a little more effort, the raw sienna is almost perfectly even. In the example at right, the drawing board was not cushioned. The colors were applied with the same amount of pressure, yet the result, by comparison, is very uneven.

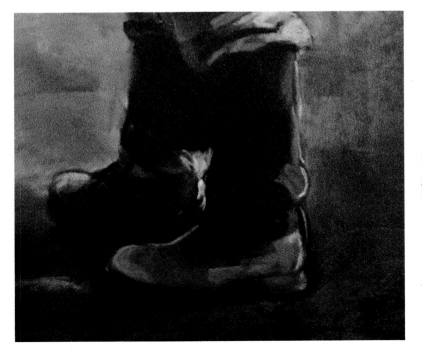

Soft and hard edges. This detail shows the varied handling of edges in The Greek Shepherd. Soft edges appear to recede and fade gradually, whereas hard edges come forward and produce an abrupt change. I try to use these perceived qualities to suggest three-dimensional space and to create interest. I begin by painting all the soft edges so that the edges of the forms recede. Then I very selectively add hard edges to the areas I want to project or accent. In the detail, for example, the use of hard and soft edges helped create a sense of space between the front and rear boots. The interplay of the edges also creates interest and is an important element in the composition.

"IMPRESSIONISTIC" BROKEN COLOR APPROACH

This technique can be used on any ground, but it is especially suited for a rough surface. It automatically fragments the pastel strokes into tiny color fragments that resemble the broken color used by the Impressionist painters. Use a rough surface if you like an impressionistic effect, and stick to a smooth surface if you prefer a highly refined, blended effect.

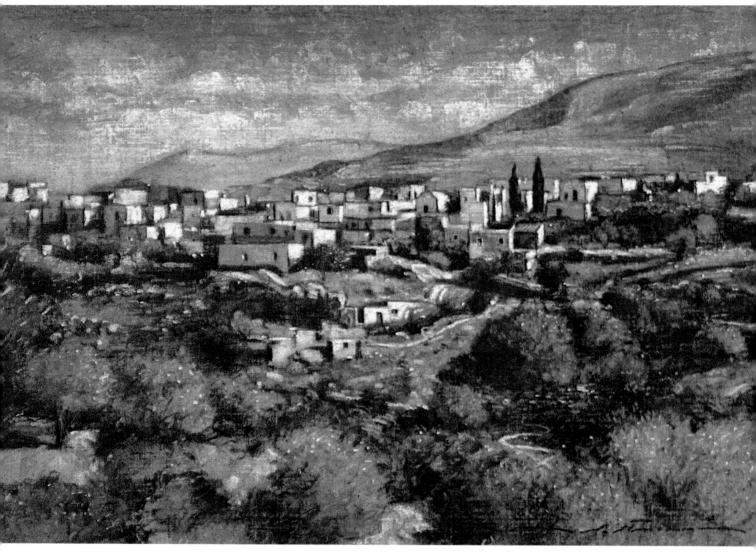

MOUNTAIN HAMLET, *linen-covered mat board, 20" × 29" (51 × 74 cm). Collection Tomi Fitzgerald.*

This little village in Crete seemed perfectly suited for an impressionistic handling—which is why I chose to use rough linen. My main interest was in the wonderful decorative patterns formed by the maze of buildings, pathways, and trees, and details were only a secondary interest.

"Impressionistic" broken color. This demonstration shows the broken color effects of texturing and scumbling—the primary techniques used in **Mountain Hamlet**—over a rough linen surface. The short strokes and dabs of color tie in well with the texturing effect and were used to create tiny scattered accents of light throughout the painting.

Dabbing. In this detail, you can see here how small dabs of light colors were scattered across the forms to produce tiny accents and a subtle animation of the colors.

Texturing. This detail shows how texturing and scumbling were used to develop the forms. The buildings were handled as simple masses, and detail only suggested.

MIXED MEDIA

Pastel can be combined with many different media to produce exciting and unusual results. The purpose is generally to work out problems of color and composition in an underpainting, but the additional medium also adds depth and variety to the paint quality of the pastel painting.

COMING ASHORE, *museum rag board, 28" × 39" (71 × 99 cm). Collection Dr. and Mrs. Thomas J. Weatherall.*

This painting of the West Indies was one of my first large-scale pastels. It evolved from my watercolor painting experiences and my fascination with the effects of light and optical color mixing. I discovered that transparent watercolor beautifully complements the opaque strokes of pastel and that the interplay of the two can produce vibrant color combinations. This simple observation became the basis of the technique employed in the painting.

Watercolor underpainting. *Pictured here is an indication of how the underpainting appeared in* Coming Ashore. *The washes were applied in a loose, simple manner over a charcoal drawing. Halftones and darks dominated, and no white paper was allowed to remain. The hazy look of the washes was caused by the rag board, which had been roughened with sandpaper to create more tooth for the pastel.*

Pastel strokes. *This is a breakdown of the various strokes used in the painting and the way they interact, causing an optical blending of color. They are seldom isolated so clearly, however. For the most part, the strokes are integrated throughout the composition, creating a network of broken color.*

Texturing

Hatching

Crosshatching

Watercolor underpainting

Dabbing

Detail. *This closeup shows how the pastel strokes interact with each other and the watercolor underpainting. The forms being painted had a definite influence on the type and direction of the strokes used, but consideration for the overall unity of the composition was the highest priority.*

CONCEPT AND TECHNIQUE

An understanding of technique can give an artist the skill and tools to paint with, but creativity can only come from thinking in a conceptual way. The artist should have a clear concept—a mental image or idea—of what he or she wants to express before starting a painting. The concept suggests a direction and guidelines—from an abstract thought the artist is given a structure to work within. Technique can then be used in a judicious and creative way.

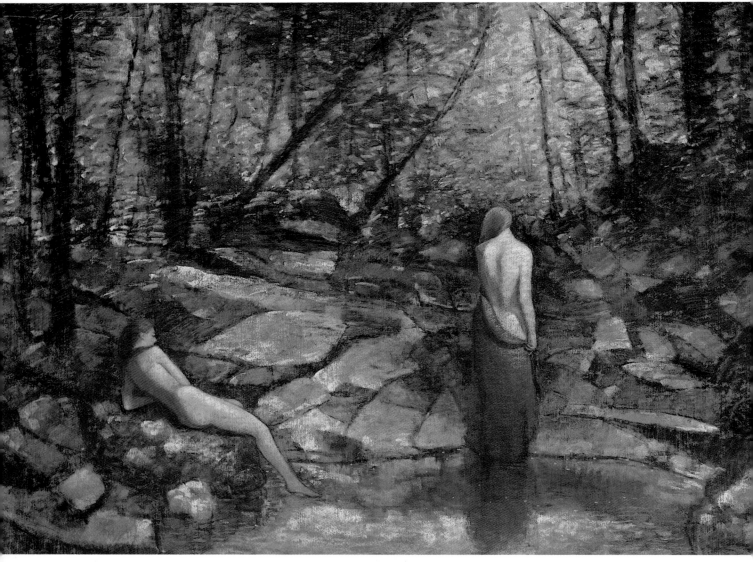

BATHERS IN THE FOREST, *granular board, 29" × 39" (74 × 99 cm). Collection Mr. and Mrs. Michael B. Gustafson.*

The concept for this painting evolved from a small pastel study, Nude with Red Robe, *that I completed directly from the model. The figure seemed to have a grace and classical quality that intrigued me. I envisioned her in a peaceful, romantic setting, and the forest scenes of Corot immediately came to mind. With that concept, I began to play with composition ideas in little rough, very abstract sketches, and worked out the details in the line drawing, directly on the pastel ground. The reclining nude developed as an afterthought to counterbalance the standing figure.*

The forest was invented from my concept. Its tranquil, cool colors and shimmering light were orchestrated to enhance the warmth and radiance of the figures.

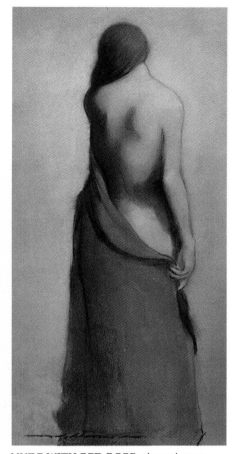

NUDE WITH RED ROBE, *charcoal paper,*
24" × 12" (61 × 30 cm).

This is the study that inspired
Bathers in the Forest.

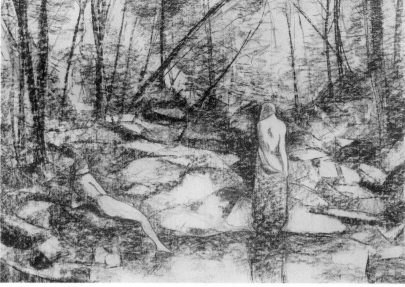

Underdrawing. *The drawing was sketched in with vine charcoal and then shaded with Nupastel black. Underdrawing allows me to develop a composition first as a value abstraction and to construct the forms with value. This step creates a solid foundation to build a painting on and simplifies the painting procedure.*

Dabbing

Blending

Texturing

Feathering

Scumbling
and feathering

Detail. *Texturing, scumbling, and blending were the predominant techniques employed, but scattered strokes of dabbed color produced the effect of broken light through the trees. Some feathering with pastel pencils also helped to refine the details and unify the composition.*

MOOD AND TECHNIQUE

Every element of painting—color, value, line, form, texture, and paint quality—can suggest a mood. The artist must carefully orchestrate these with the painting techique to create the mood that is wanted. Materials, procedures, and paint strokes must work in accordance with the mood and be well thought out before the painting is started.

This painting depicts flambeau carriers like those that have lighted the way for night parades in New Orleans since the nineteenth century. Although the custom is actually festive, the visual drama of it has a mysterious, haunting almost primeval quality. To portray this mystical mood, I used a hot, dark palette and emphasized the dramatic lighting (chiaroscuro). The dark tones were established in the black underdrawing, and the colors were blended, scumbled, and textured over it. I was very careful not to let any visible paint strokes show, which would have destroyed the continuity of the technique and also weakened the sense of form and space.

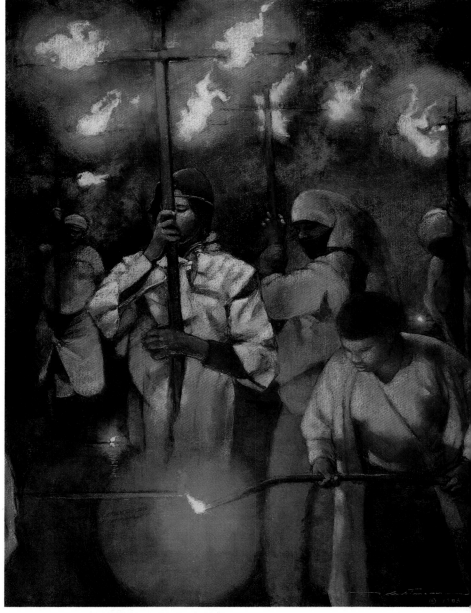

MARDI GRAS FLAMBEAUX, *granular board, 39" × 31" (99 × 79 cm). Collection Joseph F. DiMaria.*

Texturing and impasto. *This detail shows the dramatic texturing and impasto (heavy pigment buildup) on the dominant figure in the painting. The key to the effect was the rough granular ground and the heavy application of fixative between color layers.*

Blending and scumbling. *Here you can see how blending and scumbling helped create a soft, hazy atmosphere and unity between the figure and the background.*

Blending, scumbling, and texturing. *I worked back and forth with blending, scumbling, and fixative until I was able to establish a sense of form and translucency in the flames and the halos around them. Then the most brilliant lights of the flames were textured in with intense yellows.*

97

FORM AND SPACE

Besides adherence to the principles of linear perspective, there are a few other concepts about form and space that I use as a guideline in my work. The first is that objects in the foreground generally have sharp clarity, but as they recede, they gradually become less and less distinct. The second is that a dominant light source in a painting dramatically defines the forms and creates believable three-dimensional effects. The third is that thin, transparent, dark, cool, and grayed colors appear to retreat in space, whereas thick, opaque, light, warm, and intense colors appear to advance.

The painting procedures I use—working from dark to light, cool to warm, thin to thick, suggestion to refinement—go hand in hand with these concepts.

POTATO HARVEST, *granular board, 24" × 34" (61 × 86 cm).*

All of the principles and concepts mentioned above are used here to create a sense of form and space. The linear perspective is especially apparent in the converging lines of the rows of earth and in the gradual size reduction of objects as they recede. The figure and objects in the foreground are clear and well defined, while objects in the distance are blurred and indistinct. A dominant light source is coming from the left and slightly to the rear, which produces a dramatic modeling of all the forms. The dark areas (usually shadows) of individual objects are painted thinly and relatively cooler than the light areas, which are generally warmer and painted thickly. Overall, the colors in the distance are cooler and grayer.

Aerial perspective. *Objects in the distance are less distinct, cooler, and grayer because of the interference of moisture and dust in the atmosphere. This diagram shows the sketchy way the trees were handled and how optical blending (texturing and scumbling) was used to create the hazy color effect of aerial perspective. At the bottom are splotches of the various colors used in the sky.*

Painting procedure. *The step-by-step development of the painting is illustrated here. Some of the black underdrawing (on the brown granular ground) remains uncovered in the potatoes (at left). The baskets show the initial color lay-in after it has been blended, and most of the potatoes are in the build-up stage. The development is essentially dark to light, thin to thick, and suggestion to refinement. At the bottom are splotches of the colors used in the potatoes.*

Detail. *To produce the solid modeling of the figure, initially I painted it much lighter overall than it appears now. Then I used fixative and some umber and yellow spray glaze to darken the colors and give them a translucent quality. This also fixed the pigment thoroughly, enabling me to add the dramatic impasto lights on the back of the figure.*

THE IMPORTANCE OF SIMPLICITY

If you were trying to make someone understand a complex idea, you would explain it in the simplest terms possible in order to be clearly understood. Painting is very much the same. Even the most complicated subject must be presented in a simple manner if it is to have a positive impact on the viewer. Details must be secondary to the clarity of the overall composition.

Sometimes economy is the best means of simplification. Reducing the subject and the concept to bare essentials can be much more powerful than cluttering the composition with trivialities just for the sake of painting everything that is actually there.

My primary interest in this painting was the quiet mood and the angelic personality of the little girl. Anything that did not contribute to this objective was downplayed or eliminated. Therefore I reduced the color selection to only the most essential and limited the number of pastel strokes to as few as possible.

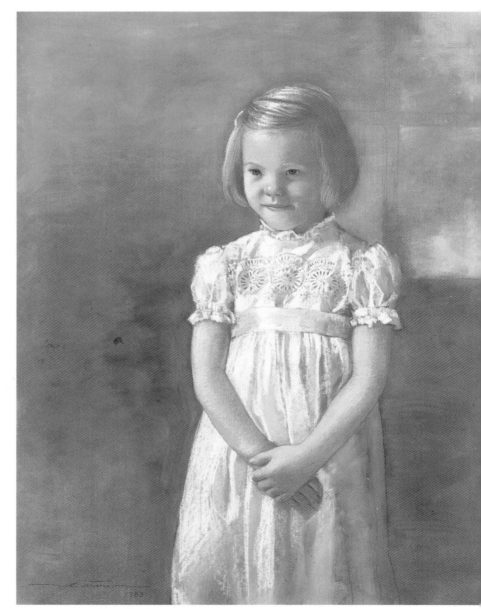

LITTLE GIRL IN WHITE, *fine granular board, 30" × 24" (76 × 61 cm).*

Pastel washes. *One way I prevented the limited color selection from becoming monotonous was to vary the handling of the color. This diagram shows how I created the washes in the painting. At the top are the soft pastel colors as they appeared when first sketched in. Below them are the same colors after I worked into them with a wet sponge. The darker, more transparent tones are the first wash. After they dried, I applied the lighter colors and then worked into them with a wet bristle brush, creating a slightly opaque wash.*

Painting procedure. *This sketch demonstrates the step-by-step development of the painting. On the left, some of the original sepia pencil drawing done on the ochre-colored ground still remains. I sprayed it with clear acrylic fixative and applied the pastel washes over it. I gradually developed the forms and details with Nupastels (seen here as they appeared when first blocked in). The Nupastels used in the dress are sandalwood, flesh pink, peach, and ivory. I also used an ivory soft pastel in some areas to build up a slightly heavier pigment layer.*

Paint strokes. *First I textured in the colors (as indicated at the upper left) to establish the basic form, then refined the forms with a feathering technique (as indicated at the right and bottom left of the arm). The two techniques work well together to create subtle transitions without the need of blending. The flesh tones were painted with sanguine, sandalwood, salmon pink, and flesh pink Nupastels and a light sunproof-orange soft pastel.*

101

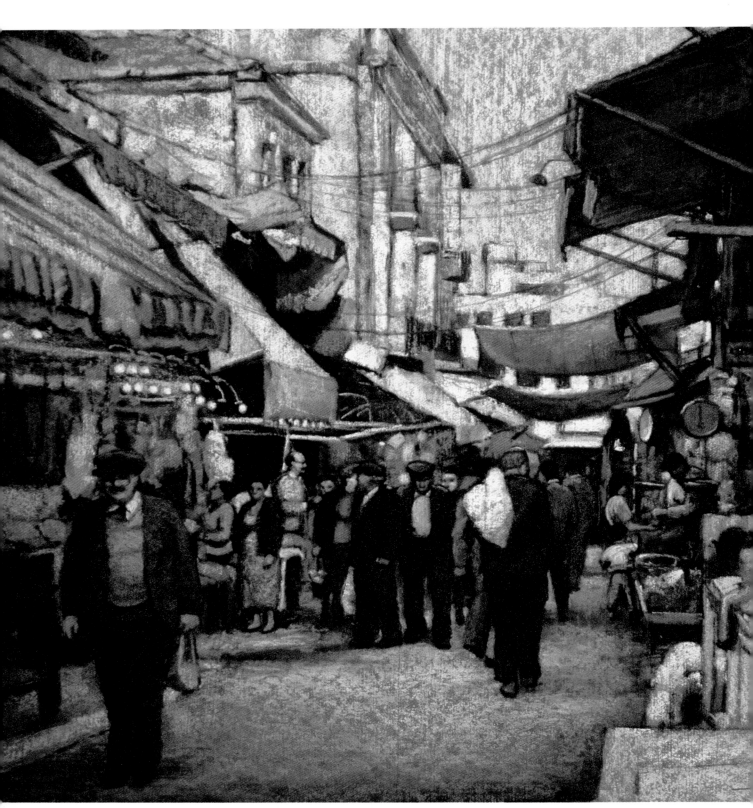

IRAKLION MARKETPLACE, *granular board, 18" × 24" (46 × 61 cm). Collection Jacqueline Ledger.*

Demonstrations

The demonstrations presented here illustrate the major pastel techniques I employ. Although there are differences, each proceeds in an orderly, well-thought-out manner. In addition to describing the various steps, the commentary also shows how knowledge, logic, and imagination are all essential to creating a successful painting.

Technique on Fine-toothed Surface

The beautiful redhead in this portrait is my sister-in-law, Gayle. Because it was difficult to arrange our schedules to do the painting from life, I used a 35mm color slide I took of her one afternoon as my reference. Slides are much more lifelike than prints, and I find them convenient and easy to work from.

Step 1. Preliminary drawing. The surface is the smoother side of a sheet of gray Canson Mi-Teintes pastel paper. I loosely block in the drawing with a sanguine Conté pencil and shade with a sanguine Conté crayon. Then I blend with tissue, which leaves only a soft impression and also tints the paper. Now I draw more carefully with the sanguine pencil, using the first impression as a guide. Once more I soften with tissue, then refine with a sepia pencil. The blending allows me to refine the image more carefully with each redrawing. The Canson paper is much smoother than I am used to, and I want more tooth. As an afterthought, I roughen the surface with coarse sandpaper until a slight nap is raised. I refine the drawing a bit more and then spray it with several coats of workable fixative.

Step 2. Color lay-in. Using the side of the pastel, I establish the lights of the face simply with a medium-value fresh tone. The sanguine drawing and gray paper serve as the shadow color. This immediately creates a strong sense of modeling. I add cadmium red to the lips and then scumble a red-orange into the cheeks and a little into the shadows and the hair.

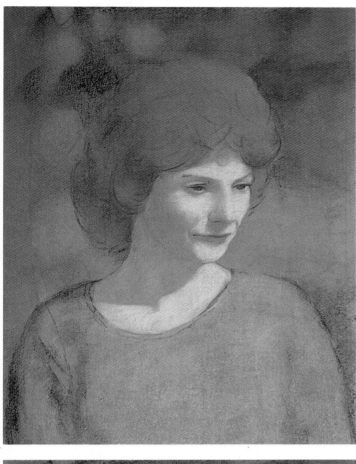

Step 3. The color lay-in is completed over the rest of the drawing. It is essentially very warm, with the olive-green serving as a subtle complement. I now blend most of the colors with tissue, giving them a transparent, veil-like appearance. The value contrast is increased, and I draw in some lines with dark browns and greens. Before proceeding, I spray the pastel again with several coats of workable fixative.

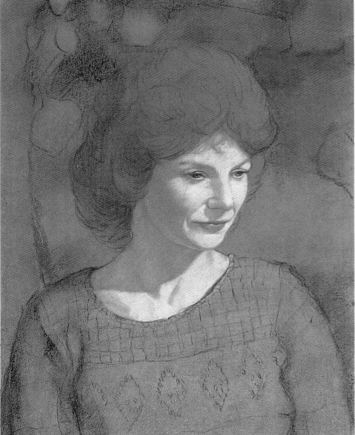

Step 4. Color buildup. With a very light yellowish pink, I bring out brighter lights in the face and neckline. I use vivid reds, pinks, and oranges to intensify the lips and cheeks. I also develop the forms in the shadows of the face using these intense colors, along with several muted Nupastel colors—especially #233 raw sienna, #313 nut brown, and #408 fern green. I employ a light skimming stroke with the side and tip of the crayons. Sanding the paper gave it a delicate nap that I do not want to lose by overloading it with heavy strokes. I also continue to blend the colors using a soft sable brush. I refine the head a little more and redraw the pattern of the sweater.

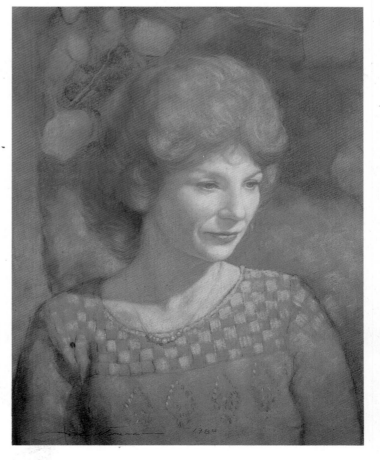

Step 5. The color buildup continues. The forms in the hair and background are developed with stronger lights and darks. I scumble a lighter green into the sweater and bring out its decorative pattern. I do a little more work on the face, and the portrait is nearing completion. I have been trying very hard not to be too literal and to keep the overall image soft and somewhat suggestive. However, there are still refinements to be made, so I spray the pastel again fairly heavily with workable fixative.

Step 6. Finishing. Now I develop the face with thicker color and highlights, but the effect seems slick and pasty compared to the other colors. To remedy the problem, I gently blend the thicker color with a soft sable brush. This removes a small amount of pigment and uncovers the delicate texture of the paper. The pigment buildup is much thinner than I usually work for, but on this surface it has a soft, translucent quality that appeals to me. The effect is very much like that of pastel portraits that were so in vogue in the eighteenth century. I proceed to develop the lights in the hair, background, and sweater in the same manner as the face; that is, I lay in the color fairly heavily, then gently blend it with the sable brush. Some areas need to be a little darker, so I spot-spray them with workable fixative. I draw in the necklace inconspicuously, touch up a few details, and the portrait is finished. Considering that the pigment buildup is relatively thin, the final fixing is very light.

PORTRAIT OF GAYLE, *Canson paper, 20″ × 15″ (51 × 38 cm). Collection Mr. and Mrs. Gerald Flattmann.*

106

Technique on Fine-toothed Surface

This is one of a small series of arrangements I painted incorporating reproductions of the work of some of my favorite painters. I usually let the reproduction set the key for the color scheme and the selection of objects for the arrangement. In this case the painting is Whistler's *Symphony in White No. 2: The Little White Girl.* Typically his color scheme is low key and the composition includes a couple of oriental objects (hence, the inclusion of the oriental vase in my arrangement). The Time-Life Library of Art book is opened to a chapter titled "A Search for Simplicity," which seems particularly appropriate for the title of my painting as well.

Step 1. Toning paper and preliminary drawing. The surface is a fine-grit sanded paper (Ersta 5/0) that has been mounted on foam board for support. It is toned with a light wash of burnt umber and alizarin crimson oil paint that has been highly diluted with turpentine. After I apply the color with a large brush, I gently buff the surface with a soft cloth to even the tone. When the wash is dry, I block in the drawing and shade with sepia Conté pencils and crayons. Then I spray heavily with workable fixative.

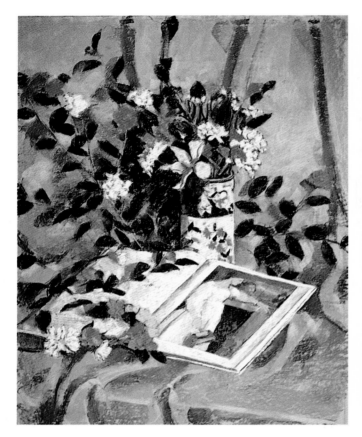

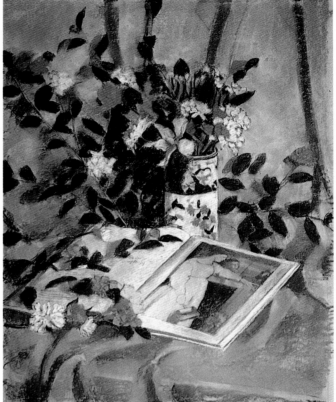

Step 2. Color lay-in. Using the side of the pastel, I establish the local colors in a broad, simplified manner.

Step 3. Blending. I carefully blend the colors with various brushes to even the tones. Then I spray the pastel heavily again with workable fixative. Basically, this makes the tones darker and somewhat transparent, letting more of the preliminary drawing show through.

Step 4. Color buildup. The forms are now established solidly with heavier, more precise pastel strokes. I employ mostly the side of the pastel but also begin to use some linear strokes for detail and delicate hatching. The paper does not accept the side strokes as evenly as I expected—the pastel crayon seems to skip over areas, producing an irregular pattern. I can feather the colors to even the tones, but somehow blending seems more appropriate for this painting. It is done with a wide soft sable brush throughout the picture. The composition seems somewhat unbalanced, and I reshape the drape on the right side to counteract the greater amount of activity on the left. I again spray the pastel with workable fixative.

SEARCH FOR SIMPLICITY, *fine-sanded pastel paper, 27" × 21" (69 × 53 cm).*

Step 5. Finishing. Subtle refinements are made now, especially on the lettering and reproduction in the book. I work a little more light bluish gray into the cloth and the dark upper right corner to create more activity and interest. I touch up and strengthen some colors, then add the final highlights. I spray the completed pastel lightly with workable fixative.

Technique on Rough Surface

The subject of this painting came from one of many hundreds of photographs I took on a six-week visit to Israel and Egypt in 1980. The information I recorded with a camera probably would have taken two years with a sketchpad. As great an aid as photography can be, however, it can also be a major block to creativity. The great danger, of course, is that the artist can easily be drawn into producing paintings that are not much more than elaborate enlargements of photographs.

My heartfelt advice when working from a photograph is to take only the information you need from it, then synthesize that with your recollections of the subject. Do not be afraid to rearrange, borrow, or invent. Be subjective—for a moment forget the photograph altogether and think about how to express the feeling or mood you want using color, composition, and technique alone. Then with the aid of the photograph, make it all materialize as your personal expression. If you can manage all this, you will be the master of the photograph, not its slave.

Step 1. Preliminary drawing. The surface is a heavyweight cold-pressed illustration board prepared with a dull gold-colored pumice ground. First I block in the drawing and define it with vine charcoal lines. Then I very carefully add value and further refine the drawing with black hard pastels (Nupastels). I use the sides of the pastels to establish the large black areas, but I execute most of the drawing with the tips of the pastels sharpened to a point. Then I spray the drawing heavily with workable fixative.

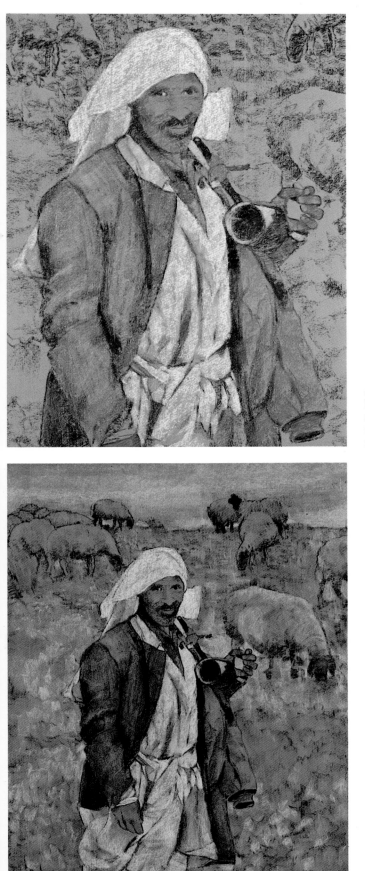

Step 2. Color lay-in. Using the broad sides of soft pastels, I begin to lay in the local colors on the figure. There is little attempt to model with color now; mainly I am trying to set the key for the color scheme. I want it to be subdued, but not monochromatic.

Step 3. I apply color over the rest of the drawing, establishing a simple complementary color harmony—blues and grays against dull reds and browns. With a large brush, I blend the pastel, which deepens and evens the tones. Again I spray the painting heavily with workable fixative, which binds the pigment more securely to the ground and darkens the colors a little.

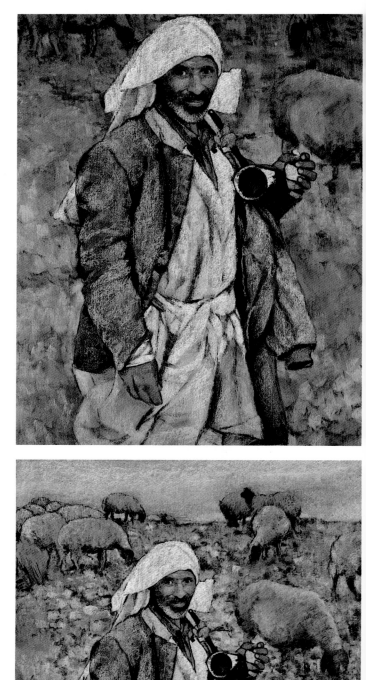

Step 4. Color buildup. I refine the figure and lay in brighter lights. I use the tips of the soft pastels and several sharpened hard pastels to develop detail, but still apply broad areas of color with the sides of the pastel crayons. The tips of the pastel crayons tend to dig deep into the ground, whereas the sides strike only the surface tooth, revealing the pronounced textural quality of the ground. Hardly any blending is necessary at this advanced stage of the painting—perhaps only a little with a small bristle brush to soften an edge or subdue a color slightly.

Step 5. The background is now better defined with dark umbers and grays. This achieves a better unity with the deep, well-defined lines of the figure. After establishing the darks, I use the sides of the pastel crayons to develop the light patterns of the rocky hillside and the sheep. Once again I spray the painting fairly heavily with workable fixative.

112

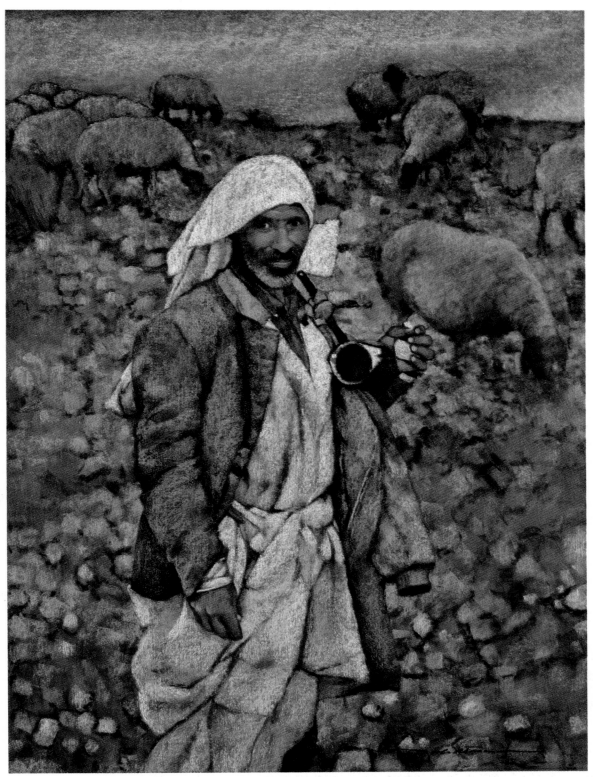

BEDOUIN SHEPHERD, *granular board, 38" × 28" (97 × 71 cm). Collection Claudia Riedlinger.*

Step 6. Finishing. In order to produce the most effective accents on the forms, I have waited until now to add my brightest lights. I also further deepen some of the darks at this stage. By reaching the final effect through a succession of pastel layers, I have achieved an optical mixing of colors that would not be possible with one application of pigment. The multiple layers also result in an impasto effect in the light areas and a greater illusion of depth in the dark areas. The finished picture is sprayed with several thin coats of workable fixative, which does not noticeably darken the colors.

Technique on Rough Surface

I must confess that as I arranged the model with a pitcher and bowl, I was thinking about Vermeer's famous painting *Maidservant Pouring Milk*. The soft, luminous quality of Vermeer's light and the peaceful nature of his subjects have always appealed to me.

The overhead lights in front of the model are fluorescent and have a bluish cast. By contrast, the dominant light is warm and yellowish, coming from a spotlight positioned behind the model on the right. The combination makes the shadows of the flesh very cool and the lights very warm.

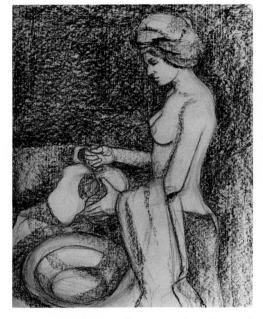

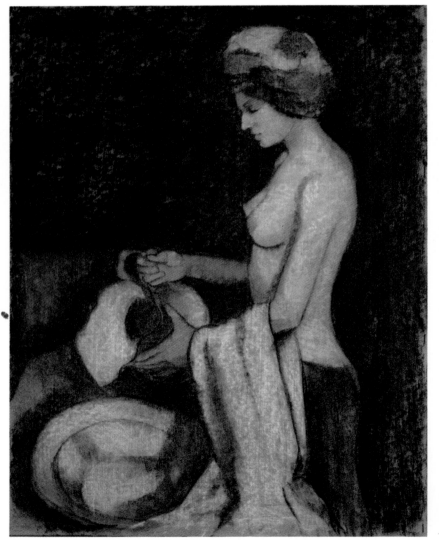

Steps 1 and 2. Preliminary drawing and color lay-in. The surface is a heavyweight cold-pressed illustration board prepared with a pale reddish brown pumice ground. The texture has a somewhat crisscross pattern and is perhaps a bit rougher than usual because a second layer of the ground was brushed on in the direction opposite the first layer after drying. After blocking in the drawing with vine charcoal, I complete a value drawing with black Nupastel and spray it very heavily with workable fixative. Using the sides of the pastels, I roughly establish the color scheme with slightly muted local colors. Next I blend them to soften the tones, then spray heavily with workable fixative, which isolates the colors.

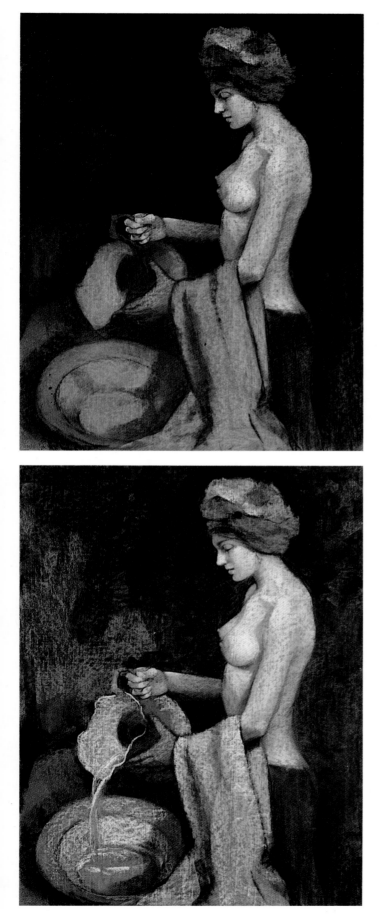

Step 3. Color buildup. The model has returned for the second session. I start by laying in highlights with light ochre, then strengthening the flesh tones with vivid golds, pinks, and oranges. The textured colors produced by the rough ground are vibrant but too coarse looking for the flesh. Rather than blending, I feather them together using ochre and pink Nupastels. Using a very dark brown soft pastel, I begin to refine the drawing of the features, torso, and hands, then deepen the tones in the background. Out of time. The three-hour posing session has gone by very quickly.

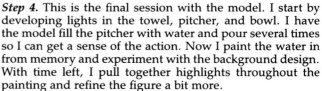

Step 4. This is the final session with the model. I start by developing lights in the towel, pitcher, and bowl. I have the model fill the pitcher with water and pour several times so I can get a sense of the action. Now I paint the water in from memory and experiment with the background design. With time left, I pull together highlights throughout the painting and refine the figure a bit more.

PREPARING THE BATH, *granular board, 29" × 23" (74 × 58 cm). Collection Sue and John Tway.*

Step 5. Finishing. Several weeks pass before I can get back to the painting. With a fresh eye, I can see lots of room for improvement. I start by applying a fairly heavy coat of workable fixative. Parts of the drawing are still somewhat crude—especially the left hand. I make the thumb smaller and reduce the size of the rest of the hand with shadow. I refine the pitcher and bowl. I decide that I prefer the simplicity of the original very dark background and darken it with black, dark browns, blue-greens, and grays. (The ground color still shows through, creating rich variation and depth in the darks.) The shoulder line, clavicle, and breasts are all too hard looking—they must be softened and refined. Even though I feather some of the colors, the texturing effect still

seems too harsh and somewhat monotonous. With a wide sable brush, I delicately blend most of the painting, softening the tones and rounding the forms.

Time to spray with fixative once again. I must try to finalize now or risk overworking. The color scheme needs to be more harmonious. I unify the blue objects by scumbling in a warm greenish blue, then repeat the color in the shadows of the flesh and background. Then I tie together the whole color scheme by carefully scumbling yellow-golds into all the lights, including the blue areas. The colors begin to have the luminous quality I am striving for. I add some subtle refinements and final highlights, and the painting is finished. It is then sprayed with several light coats of fixative.

DEMONSTRATION FIVE: FIGURES

Technique on Rough Surface

Since childhood I have been fascinated by storybook illustrations. Therefore I was delighted when the New Orleans Opera Association asked me to create the theme painting for their Hansel and Gretel Opera Ball in 1982. As luck would have it, I had the perfect models in my young nephew and niece, Matthew and Elizabeth. I took photographs of them in the woods to try to get a feeling for the story line. I am not really sure how successful the painting is as an illustration, but I had great fun doing it.

Step 1. Preliminary drawing. The surface is a heavyweight cold-pressed illustration board prepared with a pale burnt umber-colored pumice ground. I have already completed several small pencil studies of the children and made a 35mm slide of my favorite. I project the drawing on the board and trace it with vine charcoal. Then I roughly block in the woods and incorporate the witch into the design. Next I refine and shade the drawing with black Nupastel, then spray it heavily with workable fixative.

Step 2. Color lay-in. I begin to establish the local colors with the side of the pastels, making little attempt to model at this stage. I am working in a dark-to-light procedure, and the stronger lights must be reserved for later stages. I decide to limit the palette to earth colors but to use a vivid red as an accent in parts of Gretel's dress. Primarily, however, the emphasis will be on the value contrast of the children against the dark background.

Step 3. I finish laying in the local colors, then decide that the background needs more interest. With leaves I have collected from the yard, I experiment by actually pinning some of them to various areas of the picture and moving them around until a balance is found. Satisfied with the effect, I draw and color in the leaves, creating much more of an autumn scene than I originally imagined. I now blend all the pastel colors with a large brush and spray heavily with workable fixative.

Step 4. Color buildup. I build up the forms more solidly now with thicker layers of vivid, generally lighter colors. The sides of the pastels are primarily employed on the pumice ground, which produces a rich textural effect. However, I use the tips of the pastels to refine the drawing and to feather in the flesh tones. The painting is tying together fairly well now, but I still need to make a lot of refinements, so once again I spray the pastel heavily with workable fixative before proceeding.

HANSEL AND GRETEL, *granular board, 40" × 30" (102 × 76 cm). Collection Mr. and Mrs. William A. Slatten.*

Step 5. Finishing. I begin the finishing process by refining and selectively accenting the darks in the picture. Employing the sides of the pastels, I carefully bring out brighter, more impasto lights in a sort of three-step process. First I go over the forms with a warm lighter version of each particular local color. Then I gently scumble a light yellow ochre color into almost all the forms to bathe them in the same golden light. Finally, I finish the picture by bringing out the brightest highlights with a warm yellowish white. I spray the painting with several thin coats of workable fixative to protect it.

Mixed Media: Underpainting with Acrylic Washes

Still lifes are wonderful subjects to paint. They are always available and never charge a modeling fee. They are also a great way to study form and the play of light on objects. The process of selecting and arranging the objects is fun in itself and challenges your imagination and design skills.

I usually start with one or two major objects for a still life, then find others that augment it. The blue bowl came first here. The fruit and wine bottles were natural companions to the bowl because of their similar shapes, vivid colors, and general compatibility.

The dominant lighting was from a 100-watt incandescent bulb in a reflector that I positioned just a few feet to the right of the still life. The light's proximity and brilliance dramatized the three-dimensionality of the forms and the intensity of the colors.

Step 1. Preliminary drawing. The surface is the grainy or rougher side of Arches cold-pressed 140-pound watercolor paper stretched on a sheet of plywood. I block in the objects with vine charcoal, then refine and darken them with a 6B charcoal pencil. I *do not* spray the drawing with fixative because it would make the paper less absorbent for the acrylic washes.

Step 2. Underpainting. With the board in a nearly horizontal position (to keep the washes from running), I begin by toning the paper with an overall wash of raw sienna. I use a 1½" wide flat watercolor brush to apply the acrylic paint, which has been thinned with plenty of water. When the tone is almost dry, I paint in the local color of each object, then do some simplified shading with darker tones. The paper buckles somewhat and must dry and flatten out before I proceed to the next step.

Step 3. I redefine the drawing and sketch in bottle labels with black Nupastel. I also do some minimal shading with the black and then blend it in with tissue. Then I spray the painting heavily with workable fixative.

Step 4. Color buildup. Employing a texturing technique, I begin to strengthen the local colors and develop the lights of the objects with soft pastels. I refrain from putting in highlights now, but do not hold back on the intensity of the colors. There is no need to build up gradually with subdued tones—the underpainting serves that purpose. I blend the colors very sparingly. The grainy surface of the paper produces a pronounced broken color effect that I want to utilize, not disguise.

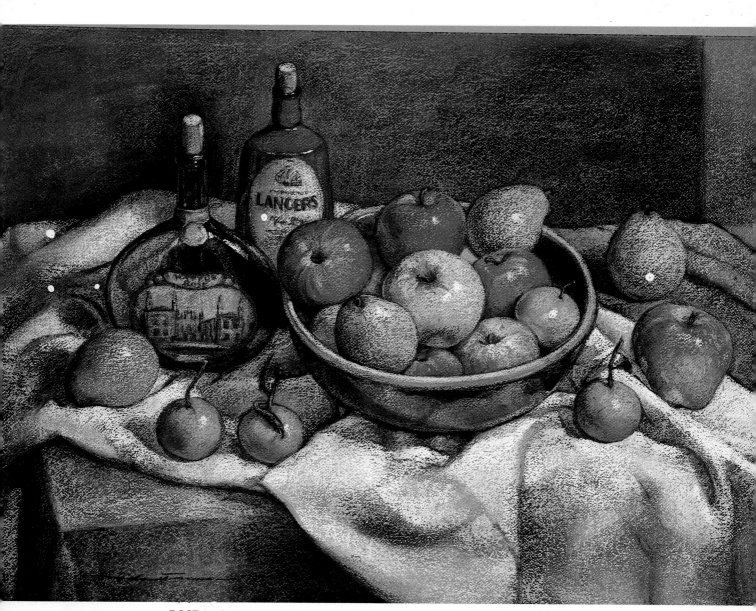

ROSE AND FRUIT, *Arches cold-pressed watercolor paper, 21½" × 29" (55 × 74 cm).*

Step 5. Finishing. I start by spraying the pastel fairly heavily with workable fixative to slightly darken its overall tonality. This will make the final accents of color appear more brilliant. Continuing to employ a texturing technique, I go over each form with warmer, more yellowish lights, then add the brightest highlights with a yellowish white. I finish by refining a few details. Before framing the painting, I spray it again with several thin coats of workable fixative.

Mixed Media: Underpainting with Oil Washes

Landscape painting has always given me a great deal of pleasure and is perhaps the kind of painting with which I feel the most expressive and comfortable. I tend to view nature with a rather abstract, poetic vision that I believe is conveyed in my work. The subject of this landscape is a typical small dairy farm, which happens to be near my home in southern Louisiana.

Step 1. Preliminary drawing. The surface is a fabric board prepared by mounting cotton muslin with rabbitskin glue to a ¼" Lauan plywood board. I block in the line drawing with vine charcoal and refine it with a 6B charcoal pencil. Then I spray it quite heavily with a clear *acrylic* fixative. Workable fixative cannot be used because the turpentine used in the underpainting would dissolve it and wash away the drawing.

Step 2. Underpainting. The oil paint is greatly diluted with turpentine to make it very lean and fast drying. I begin by brushing a wash of burnt sienna and alizarin crimson over the land area. The sky is painted in with white added to the same mixture. Then the trees and some of the foreground are made darker with ultramarine blue added to the mixture. At this point I blend the colors with a soft cloth to even the tones. Now I paint the barn, the lights in the foreground, and the upper sky with a pale bluish gray. I brush cadmium red into the sun, as well as part of the horizon and clouds, and complete the underpainting by lightly blending the colors with the cloth again. The final effect is a soft impression of the scene that is tempting to leave as it is.

Step 3. After the underpainting is dry, I re-established the drawing with Nupastel black and then spray it well with workable fixative.

Step 4. Color buildup. Utilizing a texturing technique, I bring out the barn, sky, and water puddles with pale bluish gray soft pastels, then scumble light yellows and pinks into the sky. The sun is thickly painted with a bright yellow pastel, and cadmium red is scumbled throughout the land area and into the clouds. The animals are established with a simple light and dark pattern of grays and ochres. The trees and foreground are better defined with dark browns and reddish browns.

Step 5. With a large brush, I gently blend all the colors. Then I define the trees and animals better with black lines. Having decided that the foreground needs more interest, I add the figures and more sheep. Next, I scumble more red and a bit of olive-green into the landscape and darken the ruts in the road and field. I spray heavily with workable fixative once more.

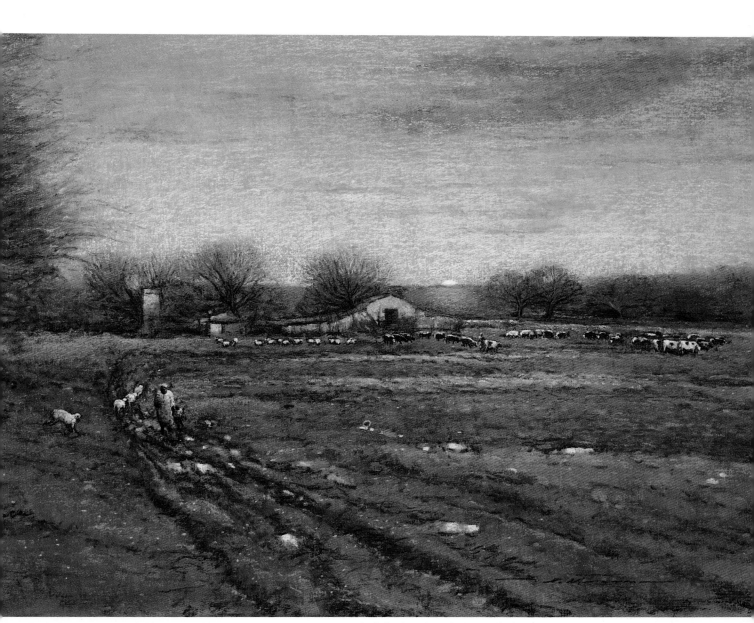

SUNDOWN, *fabric board, 24" × 32" (61 × 81 cm). Collection Mr. and Mrs. Michael T. McRee.*

Step 6. Finishing. I strengthen the colors throughout the picture with vivid reds, yellows, and pinks superimposed with a texturing technique. The fabric surface grabs hold of the pastel pigment beautifully, creating rich layers of color. I try to create more interest in the foreground by adding small dabs of pure color. Finally, I accent the major highlights with thick dabs of yellowish white pigment. Before framing the pastel, I spray it with several thin coats of workable fixative.

Mixed Media: Underpainting with Pastel Washes

This painting is based on material I collected from a trip to Crete in late 1985. I spent six weeks on the Greek island painting, taking photographs, and storing impressions in my mind. I started painting this scene on a beautiful clear morning, but as the painting neared completion, dark clouds began rolling in and the wind picked up dramatically. By afternoon, a storm passed through the area. In *Threatening Storm*, I tried to capture that sense of excitement and anticipation one feels at the onset of such a sudden change in nature.

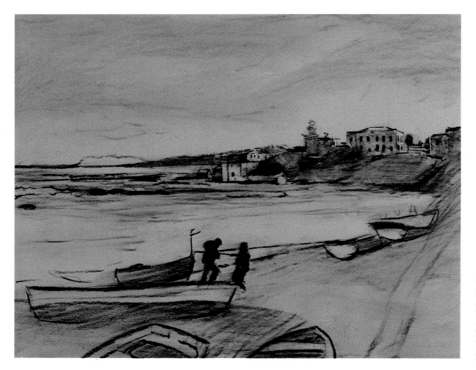

Step 1. Preliminary drawing. The surface is a medium-grit sanded pastel paper (Ersta P400) mounted with Yes paste to 3/16″ foam board. I block in the drawing with vine charcoal and spray it with several coats of clear acrylic fixative to seal it.

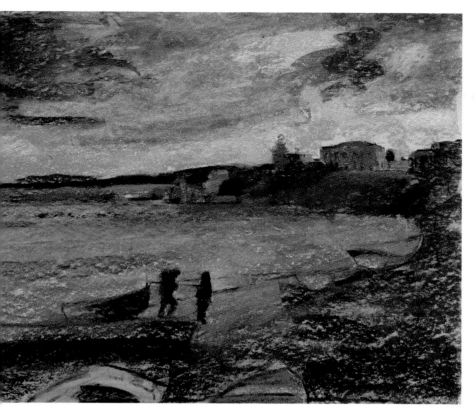

Step 2. Color lay-in. Using the side of the soft pastels, I lay in the color scheme broadly.

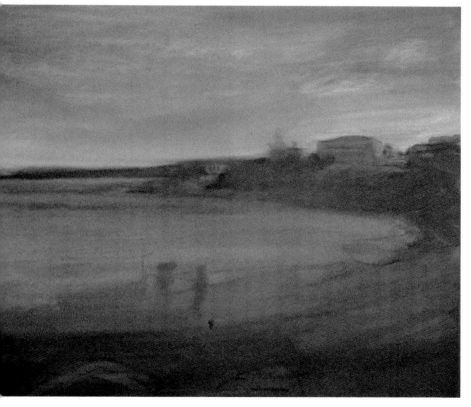

Step 3. Underpainting. I use mineral spirits to convert the color lay-in into a transparent wash, applying it with a 1½" wide, flat watercolor brush in long horizontal strokes. Wetting the pastel darkens it drastically at first—which can be a little scary—but it dries back to its original value. The painting should be placed face up when solvent is applied to prevent the washes from dripping.

Step 4. I refine the drawing and strongly shade with dark browns and grays, then spray it with workable fixative. The dramatic mood I am after is beginning to develop now.

Step 5. Color buildup. I immediately paint in the whitecaps and the brilliant sunlight on the buildings, then flood the remainder of the scene with light. Using scumbling and linear strokes, I try to create a sense of vitality and motion in the picture.

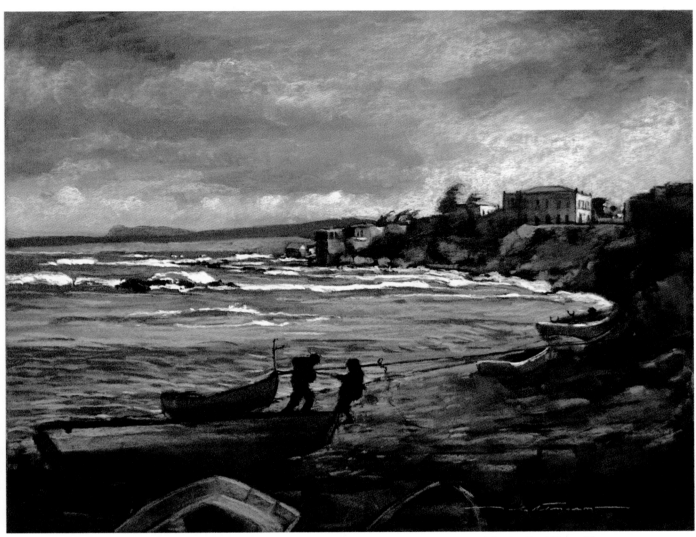

THREATENING STORM, *fine-sanded pastel paper, 22" × 28" (56 × 71 cm). Collection Tomi Fitzgerald.*

Step 6. Finishing. I use a soft brush and tissue to lightly blend and soften the sky and foreground. Then I strengthen the highlights with more pigment, and finally make the sky behind the building much lighter to counterbalance the strength of the whitecaps. I spray the finished painting lightly with workable fixative.

SELF PORTRAIT, *granular board, 27" × 18½" (69 × 47 cm).*

130

CHAPTER SIX

Framing and Preservation

Every medium of artistic expression has its shortcomings. Those inherent to pastel are vulnerability to accidental damage and mold development, although these problems are usually blown out of proportion. With proper care, pastel is extremely durable and in fact is not subject to many of the problems that affect other media. If an oil, watercolor, and pastel were hung side by side for a hundred years in average light and in a dry place, the oil painting would probably darken and begin to crack and the watercolor would likely fade, but the pastel would remain bright and virtually unchanged (assuming permanent pigments and a good-quality ground were used).

The proper care of finished pastels is the primary subject of this chapter. Good preservation practices, however, must start from the foundation up. If inferior materials are used in a painting, the artist cannot expect it to be durable. Only fine-quality materials, which are described in detail in Chapters 1 and 2, should be chosen by serious artists.

SAFEGUARDING AGAINST ACCIDENTAL DAMAGE
Framing a pastel under glass is essential because sealing it entirely with fixative would require an application so heavy that it would destroy the brilliance and freshness of the artwork. Properly done, framing shelters the pastel from dust, smearing, and other damage. It also offers some limited control of atmospheric changes and enhances the beauty of the picture.

Storing Unframed Pastels
Precautions must be taken to protect unframed pastels, which are especially vulnerable to damage. Works on thin papers should be stored flat and covered individually with a protective sheet of smooth paper or plastic securely attached so that no lateral movement is possible. Because vertical pressure will not injure pastels, they then can be stacked on top of each other or placed together in a portfolio. Be sure the storage area is a dry place and not a damp basement or closet.

Pastels on rigid surfaces require extra protection because they usually have a heavier buildup of pigment and the rigid surfaces are more prone to damage if stacked against one another. Keep the pastel on the drawing board or attach it to a stiff mounting board. Instead of a thin protective cover, secure a sheet of rigid cardboard over the pastel. An even safer method is to position a temporary mat over the pastel or simply staple strips of thick cardboard around it. This forms a raised edge on top of which can be attached the cardboard cover. In this way, the pastel does not make any direct contact with the protective cover. The pictures can then be stacked against one another without any danger of being damaged. This is also a very safe preparation for shipping or transporting unframed pastels.

Fixing Finished Pastels
Whether or not to fix a finished pastel is a subject of considerable confusion and debate. The answer is a qualified yes. Fixative definitely helps secure the pastel pigment to its support and makes the pastel less fragile, but too much fixative will darken the pastel. The amount of fixative that is applied is determined by the surface on which the pastel is painted. Works on paper generally can tolerate only very light fixing, whereas works on granular and fabric surfaces can withstand relatively heavy fixing without noticeable darkening.

To determine the amount of fixative that can be applied safely, spray the fixative on a scrap work first to test the effect on each surface. Make note of

how many coatings can be applied before the fixative begins to darken the pastel. In spraying finished pastels, always stop just short of this number or *immediately* when you perceive any darkening. Use only workable fixative with a very fine spray mist, such as Krylon Workable Fixative or Blair Spray Fix, for final fixing. After the test, lay the completed pastel face up and hold the spray can at a 45-degree angle 18″ to 24″ (45 to 60 cm) above it. Spray from side to side, starting at the top, overlapping each stroke, and proceeding to the bottom. Keep the can in constant slow motion while spraying, starting and stopping each stroke off the pastel.

If more fixative can safely be applied, turn the pastel sideways so that further coatings are applied in opposing directions. This method assures that the mist of the fixative falls on the pastel in the most gentle and even manner. However, good results can also be achieved with the pastel in an upright position if the same basic directions are followed. If the pastel is accidentally oversprayed, it can be easily retouched since the fixative also imparts extra tooth.

Matting

Like other works of art on paper, pastels have traditionally been framed with mats. Not only do mats look good, but they also provide a very safe, practical, and versatile means of preservation.

Perhaps the most important function that mats serve is to isolate the pastel from the glass. The space they create allows the pastel to breathe. Severe or sudden changes in temperature and humidity can cause paper to expand or contract, and if the pastel were in direct contact with the glass, smearing could result. Abrupt temperature and humidity changes (for example, moving a framed picture from an air-conditioned room to direct exposure in bright sunshine) can also cause condensation on the inside of the glass, which would be very harmful if it wet the pastel. Additionally, if the glass were to break, the pastel would be less likely to be damaged if a space separated them.

A single mat creates enough air space for small pictures. For pastels larger than 16″ x 20″ (40 x 50 cm) especially those with heavy pigment build-ups, a double or triple mat is better in case the pastel should bow inward. If you want to avoid the extra expense and work of multiple matting, you can simply build up the thickness underneath with strips of scrap mat board. For correct preservation matting, only 100 percent rag board should

make direct contact with the pastel surface. Thin strips of museum rag board glued to the underside of regular mat board is an economical alternative to using full sheets of expensive rag board.

Works on paper should be hinged on back of the mat only at the top. The sides and bottom should hang free to allow for expansion and contraction. If taped on all four sides, paper may buckle inside the mat. Pastels on rigid boards may be taped around the sides and bottom as well. Trim the board so that its margin is no more than an inch wider than the mat opening. Otherwise, if the pastel board should warp slightly, it might create a distracting gap between the pastel and the mat. To attach pastels to their mats, use a gummed tape. Never use pressure-sensitive tapes such as masking or clear plastic (like Scotch), which stain permanently and deteriorate quickly.

The floating method of matting is used primarily for pastel drawings on paper. The pastel is first attached to a rag board with paste or strips of double-faced tape along the top, back edge of the pastel. The mat window is then cut about ½″ wider at the top and sides and ⅝″ wider at the bottom of the pastel so that a margin of mounting board shows as a background. The pastel does not touch the mat at all and hangs free. This method is not recomended for pastels with heavy pigment buildup because the pastel can swing against the inside of the glass when it is tilted forward. However, if the pastel is mounted so that no movement is possible, the method is completely safe.

Mats create an aesthetically pleasing environment for pastels. The right mat complements the picture and harmoniously extends the pastel's tones and colors, effectively enlarging the work's overall size. There are many opinions about the proper criteria for selecting mats. So many types, colors, and textures are available that it is easy to become overwhelmed. Simplicity is the best guideline. A mat should complement a picture and not compete with it for attention. Mats that are intensely colored or have decorative patterns should be used sparingly, as they can easily overpower the picture and look gaudy.

My taste generally leans toward fairly light, muted colors for the main part of the mat. I try to pick a color that is harmonious with the picture's color scheme and slightly darker than the brightest lights in the picture. When using a double mat, I select for the inner mat a color that picks up a dominant color in the picture. This is sometimes a good spot to use a dark or intense color to create a fine accent around the picture.

If a third mat is incorporated, I make sure that at least one of the inner mats is in close harmony with the color of the main mat (a different shade or intensity of its color or a closely related color) to avoid too much contrast. An accent of a strong light might be considered for one of the inner mats, but it must never be brighter than the strongest lights in the picture or it will demand too much attention.

An alternative to the complications of selecting different color mats is to adopt the fairly standard and simple museum practice of using only cream-colored rag boards. Although this method may not enhance each pastel as well as custom selections, it is attractive and practical, particularly when a group of pastels are to be matted.

My mats are usually 2½" to 4" (6 to 10 cm) wide, with only about ³⁄₁₆" to ⅜" (5 to 10 mm) of each inner mat showing. Dimensions are determined by the size of the picture and the molding used. Small pictures or wide moldings generally require narrow mats; large pictures or small moldings usually look better with wide mats. I try to be careful that the matting and the molding are never of exactly the same width.

This is just a brief explanation of my method of matting. Of course, many other factors come into consideration and taste does vary. A picture may be matted in several different ways and look equally good. In general, though, I believe it is wiser to have the matting low key.

Molding

Molding serves the same aesthetic function as matting, and pastels often work better when framed with molding only. In fact, for pastels larger than 24" x 32" (60 x 80 cm), I usually recommend eliminating mats. The selection of oversize mat boards is limited, and the addition of a mat requires a larger glass, making the pastel more difficult to handle. If mats and moldings are combined, they should be selected at the same time. The basic principles of selection are the same as for mats. The key considerations are width, tone, and design.

Narrow moldings are often used with wide mats to cut down on expense. However, if this is not a major concern, a wide molding can be very enriching providing its tone and design do not distract from the painting. It also gives the extra support needed for large sheets of glass. When only molding is used, I prefer it to be a minimum of 2½" to 3" (6 to 8 cm) wide, even for small pictures. A handsome, wide molding can add quality to a painting, but a puny molding can debase it. A liner is an attractive way to add extra width to a molding at the least cost.

The tone of the frame should relate fairly closely to the general tonality or key of the painting. Do not select a molding that is much lighter or darker than the major value groupings in the picture. A very dark molding on a predominantly light picture (or vice versa) would be distracting. The color of the molding should complement the picture but still have a kinship to it. A gold frame against a predominantly cool or bluish picture, for example, would look wonderful if some gold color were in the picture.

The design of the molding is critical. It should have strong similarities with the design of the painting. For example, if the picture is made up of broad flowing patterns and simple shapes, the molding should reflect that simplicity by having a broad shape with long uninterrupted lines. If, however, the picture is composed of complex patterns and intricate shapes, the complexity of its design should be repeated in the molding's lines or other ornamentation. The subject matter of the painting should also influence the selection of molding. Barn wood might look great on a portrait of an old farmer in overalls but would be totally inappropriate for a painting of a Flamenco dancer, just as an ornate Spanish-style frame would look silly on the painting of the farmer. These are all simplistic examples, but they emphasize the importance of relating the design of the molding to the painting.

Glass

Although necessary for protection, glass is usually thought of as a necessary evil because it can produce distracting glare or reflections. I prefer the positive viewpoint of my agent, Bryant Allen, who has always likened glass to the final varnishing of a painting, which brings out all the richness and depth of the colors. Besides, an overhead spotlight can substantially reduce problems with glare and reflections. Another way to avoid glare is to adjust the picture wire to a longer yoke, connected to screw eyes placed just above the center of the frame, so that the picture hangs at a 5- to 8-degree tilt from the wall.

Conventional glass is most commonly used for framing because of its clarity and relatively low cost. Of the two types available, picture glass is usually preferred because it is thinner and light in weight. Thicker and stronger window glass, however, is recommended for large pictures.

Old-style nonglare glass has a surface that is etched with a microscopic grain that refracts light, but it is unacceptable for framing art because it blurs the image of the artwork. The blurring is even greater if a space separates the artwork and the glass (as is recommended for pastels). There is, however, an amazing new type of nonglare glass called Denglas. It has the same highly polished surface and sharp clarity as conventional glass, but a special optical coating reduces glare almost completely. The major drawback is its cost—currently about ten times that of conventional glass. This is obviously too extravagant for most artists, but for the collector it may be a justified expense.

Clear plastics such as Lucite and Plexiglas can be substituted for glass. Plastic is almost unbreakable, has better breathability than glass (reducing the danger of condensation), and is available with ultraviolet radiation filtering to protect the artwork from fading and embrittlement. However, it scuffs and scratches easily and tends to attract pastel dust. For permanent framing, therefore, glass is probably better, but when a painting is being shipped or is subject to continual handling, plastic is safer.

Damaged plastic can often be salvaged with a little effort. Minor scuffs and scratches can be removed by rubbing with a fine compound such as ordinary toothpaste. The best results, however, are achieved with commercial products made specifically for this purpose. One that I have used successfully is called 210 Plus plastic scratch remover, which is available through glass stores or Sumner Laboratories (see List of Suppliers). I also recommend a companion product—210 plastic cleaner and polish—that is antifog, antistatic, and is much better for plastic than glass cleaner.

Framing Directions

Pastels require a bit more care and attention when they are being framed than other media. Start by fixing the finished pastel as directed earlier. Then tap it from the back to dislodge any loose particles. If you are using a mat, tape the pastel to its back as directed earlier. Clean the glass thoroughly and insert it inside the rabbet of the frame. Clean the inside of the glass once more and use a hair dryer to blow away any lint or dust that might still remain.

Carefully lay the matted pastel face down against the glass. At this time you may consider enclosing a thymolized paper or packet (explained on page 137) behind the pastel. Next, insert an acid-free foam-core backing board. These moisture- and warp-resistant boards eliminate the usual requirement of rag paper to separate the pastel from ordinary cardboard backing. Secure the backing board at several places by driving small brads, metal points, or staples sideways into the molding. Try to do this as gently as possible. Setting the frame face down on a blanket or carpet will help absorb much of the shock. Now turn the frame face up to check for dust or lint trapped inside the glass. If there is any, you will have to remove the pastel and clean the glass again. Otherwise, add more fasteners until the contents of the frame are firmly secured. Next use 2" wide gummed tape to seal the back completely.

When a pastel is framed without the aid of a mat, it must be mounted on a stiff board. If a liner is used, it is placed between the glass and the pastel to serve as a divider. When neither mat nor liner is employed, a special clear plastic strip is available that attaches to the edge of the glass and holds the pastel about 3/16" away from the glass. As an alternative, thin strips of wood (not wider than the rabbet) may be glued to the inside of the molding between the glass and pastel.

Passe-partout

This framing method encases the pastel in an almost airtight package. The pastel (with or without a mat) is carefully placed face down against a sheet of glass cut to the same size. The backing board is placed on top of this. Then, with several pieces of tape to hold the package temporarily together, the pastel is turned face up. With great care, strips of tape are wrapped all around the edges of the glass and backing board. Only about 1/4" uniform margin of tape should show on the glass. The remainder should be tightly wrapped underneath so that no movement can occur within the package. The pastel can then be placed in a frame as usual or hung unframed with special hangers.

This method is most often employed by sidewalk artists because of its simplicity and speed. Although I do not recommend placing a pastel directly against glass for all the reasons cited earlier, this is the safest way to do it—if you must—but only for temporary purposes.

Transporting and Shipping

Any artwork covered with glass is in jeopardy when it has to be moved, and many shipping companies and art competitions even refuse to handle pictures framed in glass. In such cases, the

only alternative is to replace the glass with clear plastic—a lot of trouble. If crated properly, however, paintings with glass can be safely shipped. The key is to use a strong plywood crate and to cushion the painting firmly so that it cannot move at all. Wrap foam padding or rolled-up newspaper around all the corners of the frame to cushion the painting. You can also stuff packing material along the edges. To protect the glass from breakage, crisscross wide plastic or fabric tape over the glass (but avoid masking tape, which is difficult to remove). This may add some strength to the glass, but more important, it helps hold it together if it breaks. In addition to the tape, secure a sheet of cardboard over the glass. If more than one painting is placed in a crate, separate each with cushioning so that they cannot damage each other.

More damage is probably done to frames and paintings transported in cars than in shipping, and careless stacking is usually at fault. When six or seven paintings with glass are stacked on top of each other, a tremendous amount of weight is placed on the bottom pictures. For protection, use a sheet of corrugated cardboard between each picture for cushioning. For pictures near the bottom, a stronger board like plywood or Masonite might be advisable. Be very careful that screw eyes cannot dig into another frame or glass. I also strongly recommend stacking pastels *face up*. This avoids the possibility of the pastel sagging against the glass and reduces the chance of pastel particles being dislodged by car vibrations. Also be very sure that the paintings cannot slide around!

PREVENTION AND TREATMENT OF MOLD

Mold or mildew, a type of fungus that can cause the disintegration of organic matter, is a threat to many works of art. Its spores thrive on such materials as cloth, glue, paint films, wood, paper, and leather. It also flourishes in aqueous solutions of organic materials such as gums and carbohydrates. Mold begins as a light gray, fuzzy growth (mycelium) and may develop into a denser, somewhat colored substance, depending on its species. The most common types are *Penicillium,* usually blue-green, and *Aspergillus,* usually black or blackish, but many other varieties also occur. The growth of mold is encouraged by warm, humid, dark, and poorly ventilated conditions. Whenever the temperature exceeds 70°F and the relative humidity is above 50 percent, mold development is possible. Spores are almost always sure to be present.

Mold growth. *The white area inside the circle is about a 4× magnification of a speck of mold growing on a pastel. Although the tiny furry growths are barely detectable when they first appear, they can quickly spread if conditions are favorable.*

Mold on pastel. *Mold starts out quite inconspicuously as tiny, scattered, light gray spots that look almost like dust. The light specks within the encircled areas show how easily mold can blend in with the pastel. It must be removed and treated as soon as possible to avoid serious damage.*

Pastels are more subject to mold than most other media because the pastel sticks themselves are manufactured with binders incorporating gums, starches, and other materials that are attractive to fungi. In addition, the built-up, powdery layers of a pastel painting and the porous nature of many pigments allow moisture to be absorbed whenever the relative humidity is excessively high, creating the damp environment necessary for mold to grow within the host body—the painting itself.

As a native of the Gulf South, I am especially aware of how easily mold can grow on almost anything and just how destructive it can be if unchecked. In scientific terms, the South's hot, moist climate offers a shortened long-term aging environment. Artists living in dryer, cooler climates may not consider mold to be a threat, but it can grow anywhere when conditions are even briefly conducive. Also, since artists cannot control where their paintings go after they are sold, they should be aware of preventive methods.

In order not to be discouraging, let me put the problem of mold in proper perspective. Even in the warm, damp climate of the South, the chances of mold developing on pastels are relatively slim. Of the several hundred pastels I have completed over the past ten years or so, I have found mold on only about ten. Four of these were carelessly stored unframed in dark, damp areas along with several watercolors and oil sketches on which mold also developed. The others had no special treatment except for conventional framing with corrugated cardboard backing. Even these few occurrences, however, are unacceptable for fine art that is expected to last indefinitely. The problem prompted me to do far-reaching research, and I am now convinced that the danger of mold can be virtually eliminated with a few precautions.

Basic methods of prevention include climate control, proper framing and hanging, and employment of fungicides.

Climate Control
The ideal method for prevention of mold growth on pastels is to store and exhibit them only in an environment of circulating air that never exceeds 70°F and 50 percent relative humidity even briefly. These stringent climate controls are employed quite successfully by museums but are difficult to maintain in homes and studios. A more realistic and acceptable practice is to keep the temperature as consistently close to 70°F as possible and the humidity between 45 and 65 percent.

Proper Framing and Hanging
To a limited extent, framing creates a mini-environment for a pastel, and the humidity fluctuations in a frame are much smaller than those in a room. However, when humidity is excessively high for extended periods, moisture can penetrate the framing material and the pastel, creating a damp environment that will encourage mold growth. In addition, sudden climatic changes can cause condensation on the inside surface of the glass, trapping additional moisture in the framing. To minimize moisture absorption and retention, the following precautions should be taken:

1. Always allow an air space between the pastel and the glass.
2. Use a moisture-resistant backing board such as polystyrene foam board (regular cardboard and paper readily absorb moisture and retain it).
3. Seal the backing board to minimize fluctuations in humidity.
4. When hanging a pastel, place blocks (or push-pins) on the back corners of the frame to hold the frame away from the wall at least 1/2" and promote air circulation. Place a label on the back of the frame directing that the work *not* be hung on an exterior wall of a building, as temperature fluctuations are widest there and condensation therefore more likely to occur.
5. Never hang a pastel on any wall that is known to be damp or store it in a muggy, poorly ventilated place.

Fungicides
Fungicides work by slowly dispersing a vapor that is poisonous to microorganisms, thus inhibiting mold growth. The protection is not permanent, as all such fumigants are eventually lost to the atmosphere through vaporization. The fungicides are active for many years, however, and are reliable, worthwhile treatments. One or all of the following methods may be used, depending on how serious the threat of mold is to your pastels. (Fungicides are also toxic to humans, so use them carefully. Refer to *Artist Beware* by Michael McCann for further information.)

In the pastels. Perhaps the most effective method of mold prevention is to make your own pastel crayons, as described in Chapter 1. Binders that promote mold growth are avoided in preparing binding solutions, and a fungicide (preservative) is added to the binder. Mold growth is therefore inhibited in the binding solution and eventually in the pastel layers.

Certain pigments actually have natural, permanent fungicidal properties. Unfortunately, these are the pigments that contain lead, mercury, and copper, which are deadly poisonous and must be absolutely avoided in pastels. Pastelists of the eighteenth century, however, were not aware of the risk and used these pigments freely. Their employment of white lead (flake white) in particular may well account for the nearly perfect condition of eighteenth-century pastels.

On the support. Paper and other pastel supports can be easily mold-proofed in advance with the addition of a fungicide. Some authorities warn, however, that fungicides might have deleterious effects on the support, causing embrittlement and/or discoloration with time. From my own short-term test, I do not feel that the minute amounts of fungicides needed pose a real threat. Nevertheless, as a precaution I would advise against using fungicide on thin papers.

The simplest way to add a fungicide to a support is to spray it on. Make a solution of one quart (liter) pure grain or denatured alcohol and one level teaspoon of sodium orthophenyl phenate (or beta naphthol). Apply it with a hand sprayer to the support until it is fairly dampened. It should dry in a few minutes and be ready to use. Use the same precautions in spraying this solution as you would with a fixative.

In supplementary papers and packets. The standard preventive medicine for mold in pastels is to enclose a piece of thymol-impregnated paper (thymolized paper) in the framing between the back-ing board and the pastel. Thymolized paper is made by saturating white blotting paper or rag paper with a solution, by volume, of 20 percent thymol crystals and 80 percent pure grain or denatured alcohol. Prepare the solution just before use. Soaking is the best method to saturate the paper, but with large sheets it is easier to brush on the solution until the paper is thoroughly drenched. Allow the alcohol to evaporate completely before use. For maximum protection the paper should be cut to the same size as the picture glass. Papers not used immediately should be stored in airtight plastic bags in a dark place.

Another—and perhaps less complicated—method of incorporating the fungicide in the framing is to enclose the thymol in a small bag made of cotton cloth or filter paper (such as a coffee filter). Make the packet or sachet as flat as possible so it will not bulge against the backing board. Enclose in the bag approximately 1/2 tablespoon of crushed thymol crystals per square foot of the picture glass. For example, a glass 24" by 36" (60 × 92 cm) would require 3 tablespoons of thymol. Seal the packet with glue or gummed tape and shake it until the crystals are distributed as evenly as possible. Place the packet at the bottom of the pastel or mat, then secure and seal the backing board firmly behind it. For very large pictures you may want to divide the thymol into two or more packets to reduce their bulk. The backing board must be well sealed with gummed tape to trap the vapors within the framing. Never use pressure-sensitive tape (such as masking or clear plastic), as the thymol vapors will dissolve their rubber-base adhesives.

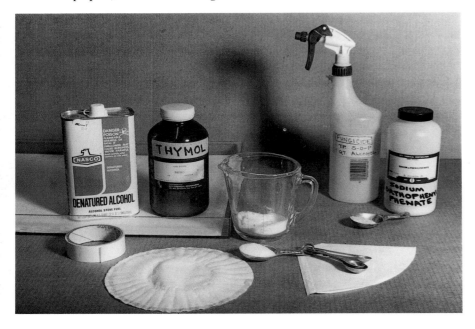

Materials for mold-proofing pastels. Thymolized paper is made by saturating white blotting paper in an alcohol solution of thymol. The thymol in its granulated crystal form can also be enclosed in filter paper bags such as those shown here to produce fungicidal sachets. Sodium orthophenyl phenate in an alcohol solution can be sprayed directly on a pastel ground before any pastel is applied.

Thymol is considerably more volatile than the other fungicides recommended. However, paper conservators Marjorie B. Cohn of the Fogg Art Museum at Harvard University and David Chandler of the Art Institute of Chicago have both reported opening frames in which thymol treatments had been enclosed five to ten years earlier, and the reek of thymol was still strong. I know of no test for the longevity of this protection, but I am sure the time span is substantial.

It is also a good practice to enclose thymolized papers and packets in portfolios, cabinets, drawers, and other areas where pastels are stored. Since these areas are not sealed, however, the thymol will vaporize faster and need to be replaced when the odor is no longer present. Moth balls, flakes, and crystals, which are quite inexpensive, can be substituted for the thymol in storage areas. Moth preventives produce heavy vapors and are effective fungicides, but they must be replenished at least twice a year as they are very volatile. Although the moth ball type of pesticide sometimes adversely affects aniline dyes, which may be present in late nineteenth- and early twentieth-century pastels, I do not think it presents a problem with today's pastels.

Removal and Treatment of Mold

Pastels subjected to dampness and other adverse conditions should be inspected carefully for mold growth (mildew). Usually it starts quite inconspicuously as tiny, scattered, light gray spots that look almost like dust. If the adverse conditions persist, the mold can spread rapidly.

When mold is found, it should be removed and the pastel treated immediately to prevent further damage. Place the pastel on an easel and carefully pick off the mold growths with a small brush. Examine the entire pastel inch by inch with a strong magnifying glass to be sure you are not missing any tiny growths that are just starting.

Many more spores that are invisible to the eye will still be present, so attempts should be made to sterilize the painting. Exposure to direct sunlight will usually kill the spores. However, the ultraviolet radiation contained in sunlight can embrittle paper and fade colors, so care must be taken not to overdose. One to one-and-a-half hours of exposure should be adequate and not cause any adverse effects.

For severe infection the best method of sterilizing the pastel is fumigation. Thymol is generally used for this purpose. Place the pastel in a tight cabinet that contains a small dish of thymol crystals (3 to 4 tablespoons should be adequate) over the heat of a 25- to 40-watt light bulb. The cabinet can be improvised with a painting crate about 6" to 12" (13 to 26 cm) deep. Raise the pastel from the bottom of the crate with strips of wood so that the vapors can circulate around it. Place the lid on the crate and seal it completely with tape. The thymol is volatilized by turning on the light for two hours. Then keep the pastel in the cabinet for one to two days more.

Before reframing the pastel, clean the glass well with denatured alcohol to kill any remaining spores. It is also a wise practice to replace the mat, backing board, and any other supplementary papers that might be infected. As further precautions, enclose a thymolized paper or packet behind the pastel, use a moisture-resistant backing board, and seal it well. Most important, try to avoid subjecting the pastel to the conditions that caused the mold in the first place.

Thymol fumigation. An old shipping crate works well as a thymol cabinet. A light bulb with a grill is rigged up and a small dish of thymol placed over it. The lid is placed on the crate and sealed with tape. The thymol is volatized by plugging the light in and allowing it to remain on for two hours, after which the pastel is left in the cabinet twenty-four hours longer. (Notice that a metal pan is under the light and foil is taped to the plywood cover to insulate the wood from the heat.)

List of Suppliers

CITY CHEMICAL CORPORATION
132 West 22nd Street
New York, NY 10011
(212) 929-2723

CONSERVATION MATERIALS LTD.
Box 2884
340 Freeport Blvd.
Sparks, NV 89431
(702) 331-0582

DANIEL SMITH, INC.
4130 1st Avenue S.
Seattle, WA 98134
(800) 426-6740
in WA: (800) 228-0458
in CAN: (206) 223-9599

NEW YORK CENTRAL ART SUPPLY
62 Third Avenue
New York, NY 10003
(800) 242-2408
in N.Y. (212) 473-7705

SUMNER LABORATORIES, INC.
210 Lincoln Street
Boston, MA 02111

TALAS
213 West 35th Street
New York, NY 10001-1996
(212) 736-7744

TRICON COLORS, INC.
16 Leliarts Lane
Elmwood Park, NJ 07407
(201) 794-3800

LIFE ON THE LEVEE AT CANAL ST., CIRCA 1885, *granular board, 27″ × 29″ (69 × 74 cm). Collection Nancy Mendloch.*

Bibliography

Canaday, John. *Metropolitan Seminars in Art, Portfolio 10. Techniques.** New York: Metropolitan Museum of Art, 1958.

Doerner, Max. *The Materials of the Artist and Their Use in Painting,* rev. ed. New York: Harcourt Brace Jovanovich, 1984.

Dunstan, Bernard. *Painting Methods of the Impressionists,* rev. ed. New York: Watson-Guptill Publications, 1983.

Koningsberger, Hans, and the Editors of Time-Life Books. *The World of Vermeer 1632–1675.** New York: Time Inc., 1967.

Mayer, Ralph. *The Artist's Handbook of Materials and Techniques,* rev. ed. New York: Viking Press, 1981.

McCann, Michael, *Artist Beware.* New York: Watson-Guptill Publications, 1979.

Pilgrim, Dianne H. "The Revival of Pastels in Nineteenth-Century America: The Society of Painters in Pastel." *The American Art Journal,* November 1978.

Prideaux, Tom, and the Editors of Time-Life Books. *The World of Whistler 1834–1903.** New York: Time Inc., 1970.

Sargent, Walter. *The Enjoyment and Use of Color.* New York: Dover Publications, 1923.

Sears, Elinor. *Pastel Painting Step-by-Step.** New York: Watson-Guptill Publications, 1968.

Weingrod, Carmi. "Artists' Papers Part I. Deterioration: Causes & Prevention." *Inksmith Artists' News,* September–October 1986.

Werner, Alfred. *Degas Pastels.* New York: Watson-Guptill Publications, 1969.

*This book is out of print but it is included in the bibliography on the chance that you may still be able to find a copy in your local library or bookstore.

Index